THE AGE OF PICASSO AND MATISSE

Modern Art at
the Art Institute of Chicago

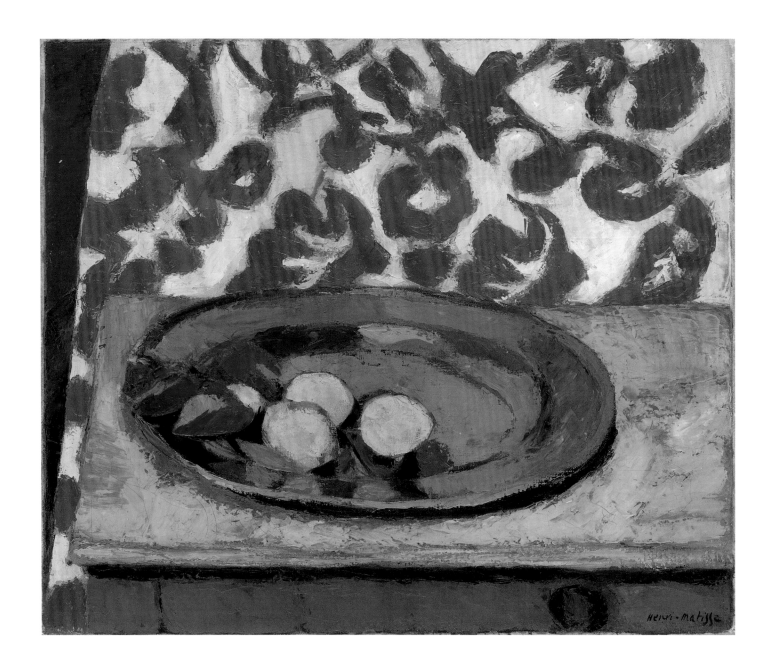

THE AGE OF PICASSO AND MATISSE

Modern Art at the Art Institute of Chicago

Stephanie D'Alessandro
with contributions from
Renée DeVoe Mertz

The Art Institute of Chicago

Distributed by Yale University Press,
New Haven and London

This book is a revised and expanded edition of *The Age of Picasso and Matisse: Modern Masters from the Art Institute of Chicago*, published in 2013 by the Art Institute of Chicago.

Revised edition
Printed in China
Library of Congress Control Number: 2014932650
ISBN: 978-0-300-20878-8 (hardcover)
ISBN: 978-0-86559-265-0 (softcover)

Published by
The Art Institute of Chicago
111 South Michigan Avenue
Chicago, Illinois 60603-6404
www.artic.edu

Distributed by
Yale University Press
302 Temple Street
P.O. Box 209040
New Haven, Connecticut 06520-9040
www.yalebooks.com/art

Produced by the Publications Department of the Art Institute of Chicago, Robert V. Sharp, Executive Director

Edited by Wilson McBee, Assistant Editor
Production by Sarah E. Guernsey, Director, and Joseph Mohan, Production Coordinator
Photography research by Lauren Makholm, Photography Editor
Photography of the works of art by Nancy Behall, Christopher Gallagher, Bob Hashimoto, and Robert Lifson, Department of Imaging
Designed and typeset in Ideal Sans and Sabon by Jeff Wonderland, Director, Department of Graphics
Separations by Professional Graphics, Rockford, Illinois
Printing and binding by Oceanic Graphics, China

Front cover/jacket: Pablo Picasso (Spanish, worked in France, 1881–1973), *Nude under a Pine Tree*, January 20, 1959 (page 61)
Back cover/jacket: Henri Matisse (French, 1869–1954), *Bathers by a River*, March 1909–10, May–November 1913, and early spring 1916–October (?) 1917 (page 46)
Frontispiece: Henri Matisse (French, 1869–1954), *Lemons on a Pewter Plate*, 1926 (reworked in 1929) (page 78)
Page 14: Works by Giorgio de Chirico and Henri Matisse on display in the Sylvia Neil and Daniel Fischel Gallery in the Modern Wing of the Art Institute of Chicago

Contents

Foreword 7

Modern Art at the Art Institute of Chicago 9

Color and Form in Early-Twentieth-Century Art 17

Vasily Kandinsky 25

Expressionism 29

Cubism 39

Marc Chagall 49

Pablo Picasso 53

School of Paris 63

Henri Matisse 73

Fernand Léger 81

Dada 87

Paul Klee 93

Abstraction 97

Constantin Brâncusi 107

Max Ernst 113

Surrealism 119

Joseph Cornell 133

Biomorphic Abstraction 137

Photography Credits 144

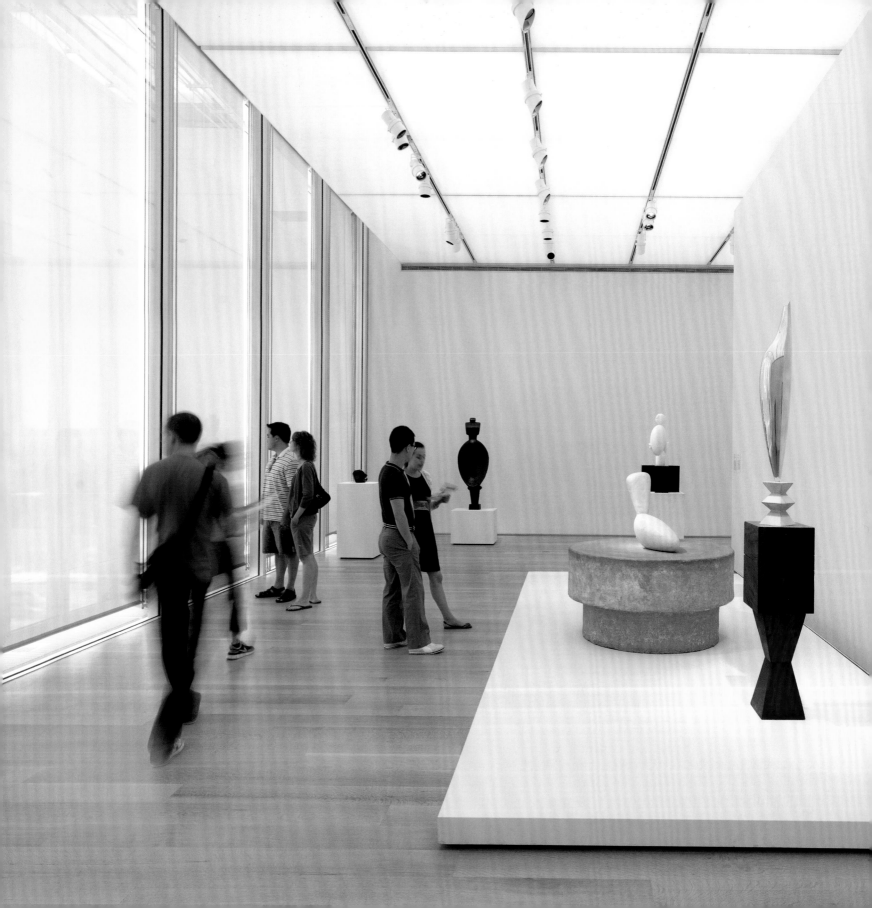

Foreword

Since its founding in 1879, the Art Institute of Chicago has had as its mission to represent art from all periods and geographic locations. The enlightened directors and curators, board members and collectors who have led the museum have always been committed to building its holdings not only across historical eras but also, critically, in contemporary art, whether that was defined as Impressionist painting, Cubist painting and sculpture, or mixed-media installations. This tradition is responsible for the Art Institute's status today as a truly hybrid museum: an encyclopedic institution committed as much to the history of art as to the new and the modern. *The Age of Picasso and Matisse: Modern Art at the Art Institute of Chicago* honors this legacy by including many of the museum's most treasured modern masterpieces in a catalogue for the first time.

This embrace of the new has been evident not only in the museum's permanent collection but also in its exhibition program. One pivotal example is Chicago's presentation in 1913 of the *International Exhibition of Modern Art*, better known as the Armory Show. With the Art Institute's early decision to host this touring exhibition, European modernism attained official sanction in Chicago, and the ensuing century would demonstrate the importance of that presentation in solidifying the city's leading role in fostering modern art in the United States.

I am delighted by the opportunity to celebrate this collection, which not only showcases great works of European modern art but also reflects Chicago's proud tradition of modern collecting: it demonstrates the city's early enthusiasm for artists who would become major international figures (Kandinsky, Matisse, and Picasso, for example), as well as the passion of local collectors for important movements such as Surrealism (Cornell, Dalí, and Miró). *The Age of Picasso and Matisse* largely represents artistic activity in France in the first part of the twentieth century, with notable examples from other areas of Europe and beyond. With such works as Malevich's Suprematist painting from 1915 and Torres-Garcia's abstract sculpture of 1932, it also highlights recent key acquisitions that speak to our continuing efforts to build upon, reappraise, and add new dimensions to our holdings of art from this seminal period.

The achievement of this impressive catalogue required the talents and vision of many individuals who deserve particular recognition here. First and foremost, I am grateful to Stephanie D'Alessandro, Gary C. and Frances Comer Curator of Modern Art, Department of Medieval to Modern European Painting and Sculpture, for conceiving of this publication and serving as its author. Additionally, in the same department, special thanks is owed to Renée DeVoe Mertz, Research Associate, for her fine essays that open many sections of this volume, and Robert Burnier, Adrienne Jeske, and Aza Quinn-Brauner, who prepared many of the works for photography. Jeff Wonderland, Director of Graphics, contributed a handsome design. In Publications, Wilson McBee sensitively edited the manuscript, with the assistance of Robert V. Sharp, Executive Director, and Lara Ditkoff, intern, and for their expert production, I am grateful to Sarah Guernsey, Joseph Mohan, and Lauren Makholm.

Since 2009, the Art Institute's modern art collection has resided on the top floor of Renzo Piano's Modern Wing, a luminous space with dramatic views of the Chicago skyline. As a complement to this stunning installation, the present catalogue provides a compelling overview of modern art practices in the twentieth century. We hope it inspires fresh perspectives and a renewed appreciation for these modern masterpieces.

Douglas Druick

PRESIDENT AND ELOISE W. MARTIN DIRECTOR
THE ART INSTITUTE OF CHICAGO

The Regenstein Foundation Gallery in the Carol and Lawrence Levy Galleries of the Modern Wing, with works by Constantin Brâncusi on display.

Modern Art at the Art Institute of Chicago

Over one hundred years ago, in 1913, the Art Institute played host to the most significant exhibition of the twentieth century: the *International Exhibition of Modern Art*, better known today as the Armory Show. In Chicago, this monumental presentation of over 650 paintings, sculptures, and drawings showcased the work of the greatest radical artists in Europe, including Constantin Brâncusi, Marcel Duchamp, Vasily Kandinsky, Henri Matisse, Francis Picabia, and Pablo Picasso, alongside their progressive American contemporaries. First presented in New York at the 69th Regiment Armory, where it generated record crowds and great public interest as well as outcry, the exhibition then traveled to Chicago and Boston, where it received similarly mixed reactions. Nearly 200,000 Chicagoans, for example, came to see the avant-garde art they had read about in the press. Some were so shocked by what they saw that they participated in a mock trial of Henri Matisse held outside the museum on the last day of the exhibition, concluding with replicas of the artist's works being set on fire. Despite the controversial response to the show and the sensational coverage in the press, it is clear today that the Armory Show introduced a broad spectrum of the American public to the visual language of European modernism and in doing so forever changed the aesthetic landscape for artists, critics, collectors, and arts institutions in the United States.

In Chicago—unlike in the two other cities, where it was presented in temporary gallery spaces—the Armory Show was exhibited at an art museum, the Art Institute of Chicago. The city, of course, was already an important center for the arts in the early years of the century: Chicago architects Daniel Burnham, Louis Sullivan, and Frank Lloyd Wright were at the forefront of developing a new urban landscape as well as architecture itself, while Sherwood Anderson, Theodore Dreiser, and Harriet Monroe were part of a thriving local renaissance of writers and poets. But the decision to present an exhibition featuring the most current, vanguard art of the time within a major civic and cultural institution—and one dedicated to the history of art—would have far-reaching effects for the city and its relationship to the arts. Despite some controversy and protest, the Armory Show exhibition in Chicago not only spurred a serious appreciation of and support for modernism in the city but also solidified the city's reputation in the United States for fostering and collecting modern art. In the end, it also inspired a very visible commitment on the part of the museum and the city at large to be a home for the new and the modern.

It was not a coincidence that the Art Institute was the only museum to host the Armory Show: since its founding in 1879, its progressive mission had been not only to educate the public about the history of art but also to serve as "a museum of living thought" that would encourage interest in the arts of all periods as well as that of the current day through temporary exhibitions and other programs. Brief though it was (the exhibition was on view for only twenty-four days), the Armory Show's effects continued to be realized throughout the city in the years immediately following, visible in the growing number of collectors, institutions, and exhibitions devoted to modern art. Indeed, this important legacy can be seen in the museum even today, as the many works in its modern collection are testament to the interest in modern art ignited by the 1913 Armory Show.

Installation view of gallery 50 of the Armory Show at the Art Institute with works by Henri Matisse, Constantin Brâncusi, and other artists.

One Chicagoan inspired by his experience at the exhibition was the attorney, collector, and art critic Arthur Jerome Eddy (1859–1920), whose *Cubists and Post-Impressionists* (1914) was the first book on modern art in the United States. Eddy had already made a name for himself as a pioneering collector of modern art: he had commissioned his portrait from James McNeill Whistler and Auguste Rodin, lobbied the administration of the Art Institute to bring the Armory Show to Chicago, and purchased widely from the exhibition. In his book Eddy praised many of the newest movements—Fauvism, Cubism, Expressionism, Futurism—and situated them within a changing world: "Failure to act to new impressions is surely a sign of age. To be very sure, the Cubists, the Futurists, and all other queer 'ists' would not make the impression they are making if there were not a good reason for it, if the times were not ripe for a change." Highlights from his own impressive collection, including Brâncusi's *Sleeping Muse* (one of the first by the artist in an American collection [1910; p. 109]), Franz Marc's *The Bewitched Mill* (1913; p. 31), Gabriele Münter's *Still Life with Queen* (1912; p. 30) and paintings by Vasily Kandinsky (see pp. 26–27; fig. 1), would join the museum's holdings in the years following his death in 1920.

The energy from the Armory Show also inspired Joseph Winterbotham (1852–1925): in 1921 the Chicago businessman donated $50,000 to the museum with the bold proposal to assemble a collection of modern art. Winterbotham stipulated that interest accrued from the investment of his funds be used to build a collection of thirty-five modern European paintings. Once the first group of thirty-five was assembled, any of these could then be sold or exchanged to ensure that the collection, "as time goes on, is [dedicated] toward superior works of art and of greater merit and continuous improvement." Not only did this provident and far-reaching gift instill within the museum's staff the fundamental practice of continually reconsidering and reappraising the strength of the modern holdings, but it made possible some of the collection's greatest icons: Balthus's *Solitaire* (1943; p. 131), Giorgio de Chirico's *The Philosopher's Conquest* (1913–1914; p. 65), Salvador Dalí's *Inventions of the Monsters* (1937; p. 130), Robert Delaunay's *Champs de Mars: The Red Tower* (1911/23; p. 45), Paul Delvaux's *The Awakening of the Forest* (1939; p. 120), Max Ernst's *The Blue Forest* (1925; p. 114), Lyonel Feininger's *Carnival in Arcueil* (1911; p. 32), Fernand Léger's *The Railway Crossing (Sketch)* (1919; p. 82), and Henri Matisse's *The Geranium* (1906; p. 21).

Just five years after Winterbotham's gift, the Art Institute made another bold step when it became the first museum in the country to devote a permanent collection gallery to modern European art. In 1919 artist

10

Fig. 1. Vasily Kandinsky (French, born Russia, 1866–1944). *Painting with Green Center*, 1913. Oil on canvas; 108.9 × 118.4 cm (43 ¼ × 47 ½ in.). Arthur Jerome Eddy Memorial Collection, 1931.510.

Frederic Clay Bartlett (1873–1953) and his wife, writer Helen Birch Bartlett (1893–1925), began collecting modern art. A year after his wife's passing in 1925, Bartlett donated the collection to the museum in her memory, explaining that "our thought has been that Chicago, the most forward-looking and advancing of cities, should have an adequate expression of modern art." Today the collection, which includes Georges Seurat's iconic *A Sunday on La Grande Jatte—1884* (1884–86) as well as Matisse's *Woman before an Aquarium* (1921–23; fig. 2; p. 75), Amedeo Modigliani's *Jacques and Berthe Lipchitz* (1916; p. 69), and Picasso's *The Old Guitarist* (the first painting by the artist acquired and put on permanent display at an American art museum [1903–04; p. 18]), stands as testimony to the couple's visionary spirit and generosity.

These gifts were matched in the ensuing years by gifts from equally spirited individuals, including Elizabeth

Fig. 2. Henri Matisse (French, 1869–1954). *Woman before an Aquarium*, 1921–23. Oil on canvas; 80.7 × 100 cm (31 ¾ × 39 ⅜ in.). Helen Birch Bartlett Memorial Collection, 1926.220.

"Bobsy" Goodspeed (later Mrs. Gilbert W. Chapman, 1893–1980), whose home was the center of much social and artistic interest in the city: in 1938, for example, as the president of the Arts Club of Chicago, Goodspeed and her husband Charles (1885–1947) were hosts to Gertrude Stein (1874–1946) and Alice B. Toklas (1877–1967). Bobsy Goodspeed Chapman would distinguish herself as an important collector, later donating to the museum such works as Matisse's *Interior at Nice* (1919 or 1920; p. 76), Piet Mondrian's *Composition (No. 1) Gray-Red* (1935; p. 105), and Picasso's *Daniel-Henry Kahnweiler* (1910; p. 41). Charles H. (1864–1956) and Mary F. S. (1861–1954) Worcester would also share their collection with the museum through the gift of such major canvases as Léger's *Composition in Blue* in 1937 (1921–27; p. 84); ten years later, they would augment their generous donations of art with funds for future acquisitions. This extraordinary gift allowed director Daniel Catton Rich (1904–1976) and the first curator of modern art, Katharine Kuh (1904–1994), to acquire one of the museum's greatest canvases, Matisse's monumental *Bathers by a River* (1909–10, 1913, 1916–17; p. 46), in 1953, and Juan Gris's *Abstraction (Guitar and Glass)* (1913; p. 44), in 1961.

By the early 1950s the spark lit from the 1913 Armory Show had grown to a flame, one fueled so passionately by the city's collectors that *Life* magazine published a feature article about "Chicago's Fabulous Collectors," who have "continued to be as vigorous and adventurous as their predecessors." Among those featured were business owner Maurice E. Culberg (1905–1953) and his wife Ruth (later Mrs. Arthur Rosenberg, 1905–1980), as well as Mary Lasker Block (1904–1981) and her husband, Leigh

11

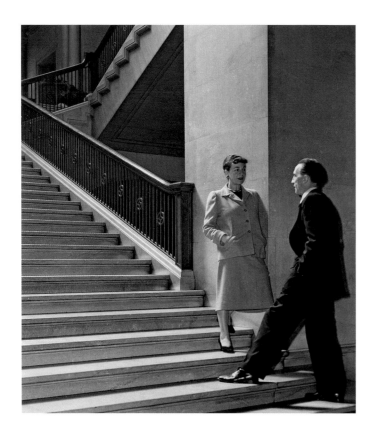

Giacometti's *Spoon Woman* (1926–27; p. 121), Matisse's *Apples* (1916; p. 74), Miró's *Painting* (1936; p. 142), and Picasso's *Head* (1927; p. 59) and *Abstraction: Background with Blue Cloudy Sky* (1930; p. 60).

That the work of the great Surrealist painter Joan Miró would feature in all these collections was perhaps not a surprise: by the 1950s Chicago was well known for its support of Surrealism. Works by Marcel Duchamp, de Chirico, Dalí, Ernst, René Magritte, André Masson, Miró, and Yves Tanguy were prominently featured by Katherine Kuh in the 1949 exhibition of the Arensberg Collection (see fig. 3) and in *Abstract and Surrealist American Art* just two years earlier, and similar shows were mounted at the Arts Club and the University of Chicago's Renaissance Society. Spurred by these presentations, and perhaps inspired by the activities of the Chicago Institute for

Block (1905–1987), vice president of Inland Steel. The generous subsequent gifts of the Culbergs, including Marc Chagall's *Birth* (1911/12; p. 50), Léger's *Divers on a Yellow Background* (1941; p. 85), Joan Miró's *Personages with Star* (1933; p. 143), and Maurice de Vlaminck's *Houses at Chatou* (c. 1905; p. 22); as well as the Blocks, including Miró's *Figure* (1932; p. 139) and *Two Personages in Love with a Woman* (1936; p. 138), have strengthened the collection in significant ways. Architect and designer Samuel A. Marx (1885–1964) and his wife, Florene May Schoenborn (1903–1995), whose collection was reported by *Life* to number "only 46 paintings and 12 pieces of sculpture [and was] a modest sampling compared to other Chicago collectors," would likewise be responsible for donating a remarkable group of works to the museum's collection, including Georges Braque's *Little Harbor in Normandy* (1909; p. 40), Alberto

Fig. 3. Katharine Kuh and Marcel Duchamp on the Art Institute's main stairway (now the Woman's Board Grand Staircase), 1949. Mirroring each other's poses, Duchamp and Kuh played on his *Nude Descending a Staircase, No. 2* (1912, Philadelphia Museum of Art), which was exhibited in the 1913 Armory Show and again in the Arensberg Collection presentation in 1949. Katharine Kuh Papers, Archives of American Art, Smithsonian Institution.

Fig. 4. Salvador Dalí (Spanish, 1904–1989). *A Chemist Lifting with Extreme Precaution the Cuticle of a Grand Piano*, 1936. Oil on canvas; 48.3 × 64.1 cm (19 × 25 ¼ in.). Gift of Mr. and Mrs. Joseph Randall Shapiro, 1996.390.

Psychoanalysis (founded in 1932), many Chicagoans began to focus their attention on Surrealism. The effect of these new currents of thought, buoyed by visits to Chicago by such artists as Jean Dubuffet (1951) and Matta (1954), ran contrary to the rational order represented by the work of László Moholy-Nagy at the New Bauhaus (later the Institute of Design) and Ludwig Mies van der Rohe at the Illinois Institute of Technology. Among the most passionate Surrealist advocates were developer Joseph R. Shapiro (1904–1996) and his wife, Jory (d. 1993), who said they gravitated to the works because of "a power and authority of image, symbol or metaphor that imbue

them with a magical 'presence.'" The Shapiros were also known for their generosity, welcoming groups to their home and even sharing their collection with students at the University of Chicago as "art to live with." Their influence on a generation of Chicago collectors is legendary, and their gifts to the museum include such seminal paintings as Dalí's *A Chemist Lifting with Extreme Precaution the Cuticle of a Grand Piano* (1936; fig. 4) and *Visions of Eternity* (1936/37; p. 128), and Ernst's *Spanish Physician* (1940; p. 117). Indeed, in more recent years their donations have inspired other collectors to make the Art Institute the home for their Surrealist works, including Miró's magnificent *Policeman* (1925; p. 141), from the renowned fiber artist Claire Zeisler (1903–1991), and thirty-one boxes by Joseph Cornell by Lindy (1918–2014) and Edwin Bergman (1917–1986).

Today the museum's collection of modern art reflects great range and depth as well as the energy and growth of our city on the world stage (see fig. 5). Much of this is due to the spirit instigated a century ago. Even in 1922, Walter Pach, one of the organizers of the Armory Show, proudly noted its effect. "Of course," he wrote to the president of the Arts Club, Rue Carpenter, "in 1913 our exhibition was a 'hard' one, and people were not prepared for it at all. Nevertheless I knew that we had sown a good seed and it is showing on the walls of the Institute." Housed prominently as the crown jewel atop Renzo Piano's Modern Wing, the collection celebrates the legacy of the Art Institute's early vision to be a place for the modern.

Stephanie D'Alessandro

GARY C. AND FRANCES COMER CURATOR OF MODERN ART
THE ART INSTITUTE OF CHICAGO

Fig. 5. Pablo Picasso (Spanish, worked in France, 1881–1973). *Maquette for Richard J. Daley Center Sculpture*, 1964. Simulated and oxidized welded steel; 41 ¼ × 27 ½ × 19 in. (104.8 × 69.9 × 48.3 cm). Gift of Pablo Picasso, 1966.379.

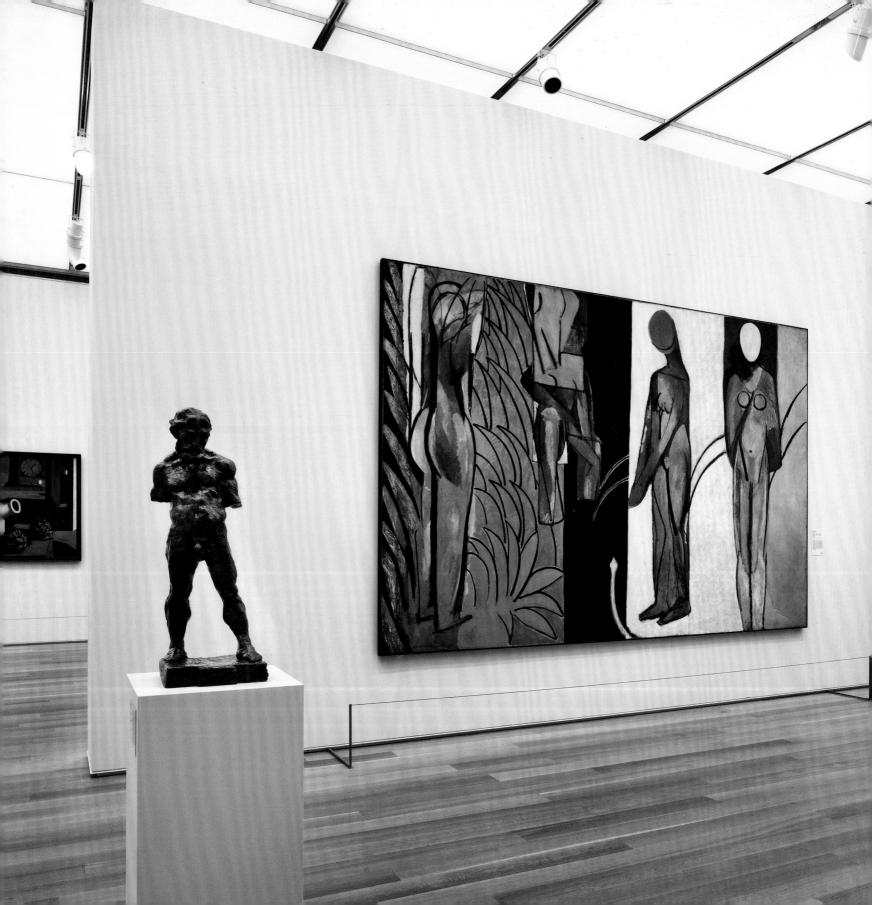

THE AGE OF PICASSO AND MATISSE

Color and Form in Early-Twentieth-Century Art

For young artists coming of age in the first years of the last century, finding their own artistic paths meant grappling with the radical ideas of the previous era. Nineteenth-century sculptors Auguste Rodin and Medardo Rosso had redefined the boundaries of the plastic arts with their use of expressive textures and fragmentation of the body. In painting, Post-Impressionists such as Paul Gauguin employed nonnaturalistic colors and simplified forms in developing a vivid and symbolic primitivism. Gauguin's art was particularly popular in the period following his death in 1903, when retrospectives of his work in both that year and 1906 reintroduced the artist to the new Parisian avant-garde.

Building on the achievements of their predecessors, progressive artists after 1900 further explored the emotional and psychological effects of the formal qualities of art. Through the use of evocative color in painting and dramatic form in sculpture, these artists imbued their subjects with a totality of feeling. Pablo Picasso accomplished this effect in his earliest mature canvases, including *The Old Guitarist* (1903–04; p. 18), in which the color blue suffuses and unifies the image in a cold gloom. Constantin Brâncusi sought to create a similar emotional intensity through greater simplicity when he reduced the contorted pose of a boy to its most essential elements in *Suffering* (1907; p. 19): no body part is superfluous, and even the fragmented arm beneath the child's heavy, tilted head adds to the sense of misery conveyed by the bust as a whole. Although real people may have inspired both works, *The Old Guitarist* and *Suffering* portray not so much the specific torments of their respective subjects but rather a deeper, psychological level of anguish.

Another offshoot of this interest in expressive color and form is the short-lived but influential movement known as Fauvism. Working directly with unmixed, undiluted color, the Fauves produced canvases that were brilliant, shockingly raw, and emotionally powerful. Henri Matisse, the leader of the group, described "the starting point of Fauvism" as the "courage to return to the purity of means." Courage is a particularly apt description for these painters, given that the radicalism of their work inspired even the sympathetic Parisian art critic Louis Vauxcelles to refer to them as *fauves* (wild beasts) after seeing their paintings in the 1905 Salon d'Automne.

The Fauves, whose exponents also included Georges Braque and Maurice de Vlaminck, applied their intensely personal vision to depictions of nature as well as the human form, and used color as the key to their responses. Works like Vlaminck's *Houses at Chatou* (c. 1905; p. 22) also reveal the artists' delight in the visible, often thickly laden brushstroke as the physical and emotional mark of the painter. Through the decisive marriage of bold hues and expressive brushwork, Fauvist paintings led to both a deeper divide between pictorial and natural realities and a greater emphasis on the evocative qualities of line, color, and form. Indeed, the emphatic divorce of color from nature championed by the Fauves would prove essential to the development of other movements, including Expressionism and Abstraction, and other artists, like Pierre Bonnard (see p. 23), who would continue to explore the emotional power of color in their work later in the century.

Detail of Georges Braque, *Antwerp* (1906; p. 22).

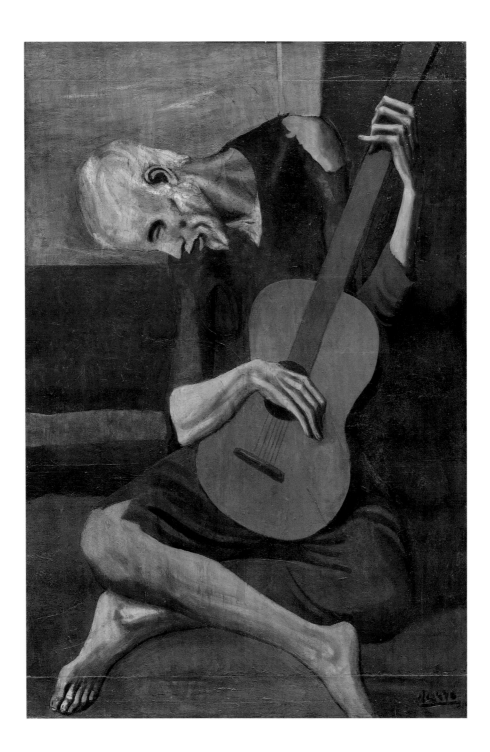

Pablo Picasso

Spanish, worked in France, 1881–1973

The Old Guitarist, late 1903–early 1904

Oil on panel; 122.9 × 82.6 cm (48 ⅜ × 32 ½ in.)
Helen Birch Bartlett Memorial Collection, 1926.253

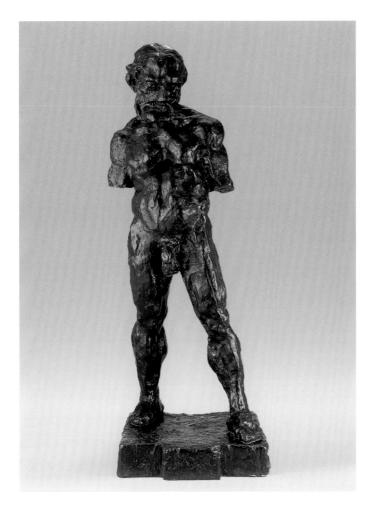

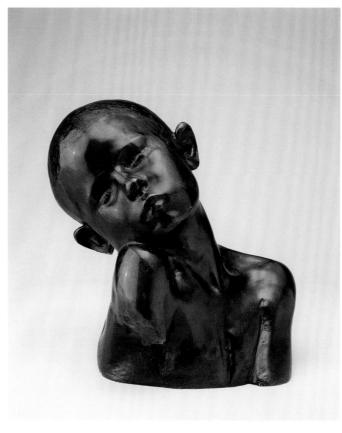

Henri Matisse

French, 1869–1954

The Serf, 1900–04

Bronze; 92.1 × 32.7 × 29.6 cm (36 ⅜ × 12 ¹¹⁄₁₆ × 11 ¹¹⁄₁₆ in.)
Edward E. Ayer Endowment in memory of Charles L. Hutchinson,
1949.202

Constantin Brâncusi

French, born Romania, 1876–1957

Suffering, 1907

Bronze; 29.5 × 28.8 × 22.3 cm (11 ⅝ × 11 ⅜ × 8 ⅞ in.)
Through prior restricted gifts of a Friend of the Art Institute of
Chicago, Kate L. Brewster, Mr. and Mrs. Carter H. Harrison,
Mr. and Mrs. Seymour Oppenheimer, and Joseph Winterbotham;
Major Acquisitions Centennial Fund, 1985.542

Henri Rousseau

French, 1844–1910

The Waterfall, 1910

Oil on canvas; 116.2 × 150.2 cm (45 ¾ × 59 ⅛ in.)
Helen Birch Bartlett Memorial Collection, 1926.262

Henri Matisse

French, 1869–1954

The Geranium, fall 1906

Oil on canvas; 100 × 81.2 cm (39 ⁷⁄₁₆ × 31 ¹⁵⁄₁₆ in.)
Joseph Winterbotham Collection, 1932.1342

Maurice de Vlaminck

French, 1876–1958

Houses at Chatou, c. 1905

Oil on canvas; 81 × 100.5 cm (31 ⅞ × 39 ⅝ in.)
Gift of Mr. and Mrs. Maurice E. Culberg, 1951.19

Georges Braque

French, 1882–1963

Antwerp, 1906

Oil on canvas; 61.2 × 73.8 cm (24 ⅛ × 29 ¹⁄₁₆ in.)
A Millennium Gift of Sara Lee Corporation, 1999.366

Pierre Bonnard

French, 1867–1947

Earthly Paradise, 1916–20

Oil on canvas; 130 × 160 cm (51 ¼ × 63 in.)
Estate of Joanne Toor Cummings; Bette and Neison Harris and Searle Family Trust endowments;
through prior gifts of Mrs. Henry C. Woods, 1996.47

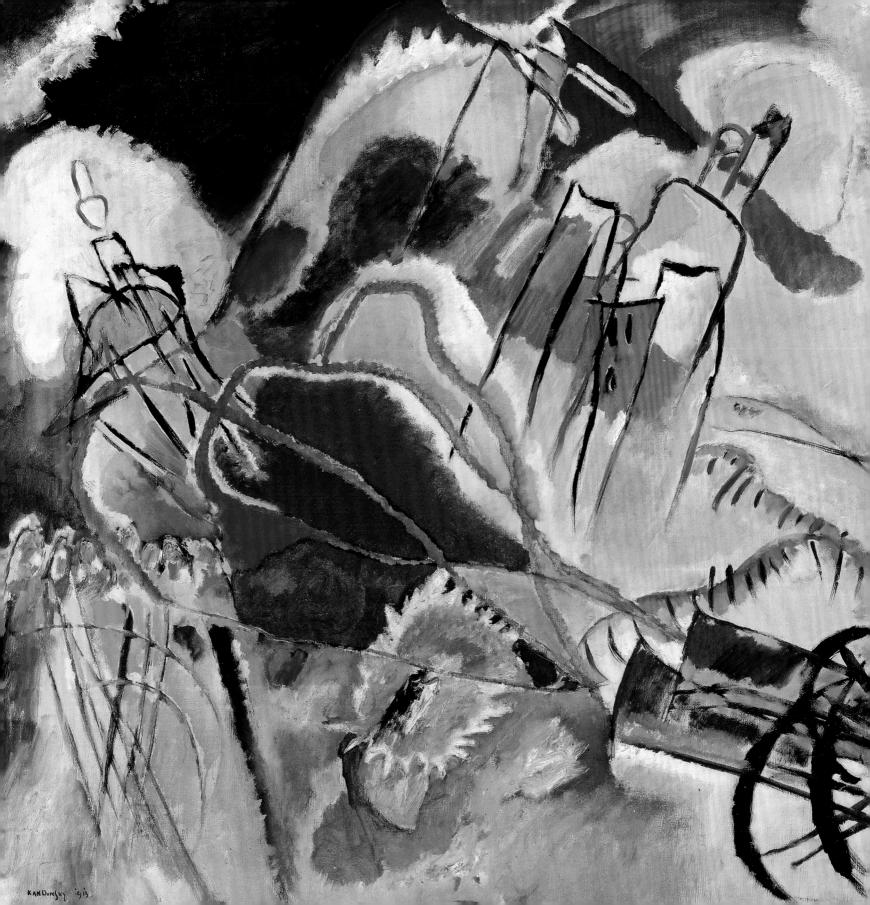

Vasily Kandinsky

One of the first artists to explore the possibilities of abstraction, Vasily Kandinsky turned to music as his model for evocative, nonrepresentational art. His resulting lyrical, color-filled compositions are visual manifestos on the power of color and form to engage the viewer on the most unconscious level.

In 1911, Kandinsky and Franz Marc founded the Munich-based artist group, Blaue Reiter (Blue Rider). This loose alliance of like-minded artists shared a common belief in the symbolic and spiritual importance of form and color and their effect on emotions. Seeking models and inspiration for his own direct, intuitive painting, Kandinsky often looked to the folk art of his Russian homeland in addition to medieval and non-Western sources as examples of pure, untutored artistic expression. While still in Russia, he often filled his canvases with romantic subject matter based on the country's fairy tales. After he moved to Germany, however, these references became more oblique as his imagery became more abstract. The title of *Painting with Troika* (1911; p. 26), for instance, refers to the suggestion of a horse-drawn sled at the left of the composition, while the work's hand-painted frame reflects a folk art aesthetic.

Kandinsky's interest in the nonobjective world led him to create some of the first abstract paintings in Western art. Believing that the "more abstract is form, the more clear and direct is its appeal," he continued to refine his thoughts about the connections between the formal qualities and emotional and sensory effects of art during his tenure at the Bauhaus, the influential art school, and throughout his life. His 1912 publication, *Concerning the Spiritual in Art*, remains a foundational explanation of his views. The text details how music, as an expressive but intangible art form, holds the key to developing an analogous abstraction in painting. Kandinsky's canvases, such as *Improvisation No. 30 (Cannons)* (1913; p. 27), reflect his belief that color and form innately possess specific abstract qualities, and that an artist, like the conductor of an orchestra, can harness them to express internal, spiritual subject matter. Asserting that color has "a material parallel in the human energy," he wrote that yellow, for instance, has "an insistent, aggressive character" that "bursts forth . . . in every direction." Kandinsky believed that creating a pleasing painting, therefore, involved composing innate formal qualities in an ideal balance much in the way the performance of a symphony stimulates its audience by combining the sounds of numerous instruments.

Kandinsky's methodically articulated theories, however, belie the artist's primary aim of producing paintings that would be direct manifestations of his internal state and cause an instinctive response in the viewer. In a letter to the legendary Chicago collector Arthur Jerome Eddy, Kandinsky hinted at the dually expressive and evocative qualities of *Improvisation No. 30 (Cannons)* when he stated that the abstracted cannons visible in the lower right corner of the work "could probably be explained by the constant war talk going on throughout the year," but that "the true contents are what the spectator experiences while under the effect of the forms and color combinations of the picture."

Detail of Vasily Kandinsky, *Improvisation No. 30 (Cannons)* (1913; p. 27).

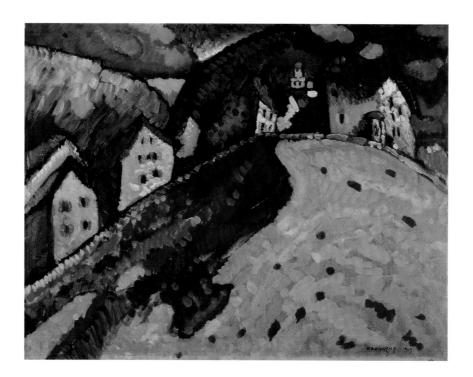

26

Vasily Kandinsky

French, born Russia, 1866–1944

Houses at Murnau, 1909

Oil on cardboard; 49 × 64 cm (19 ¼ × 25 in.)
Bequest of Katharine Kuh, 1994.33

Painting with Troika, January 18, 1911

Oil on cardboard; 69.7 × 97.3 cm (27 ⅜ × 38 ⁵⁄₁₆ in.)
Arthur Jerome Eddy Memorial Collection, 1931.509

Vasily Kandinsky

French, born Russia, 1866–1944

Improvisation No. 30 (Cannons), 1913

Oil on canvas; 110.6 × 111 cm (43 9/16 × 43 11/16 in.)
Arthur Jerome Eddy Memorial Collection, 1931.511

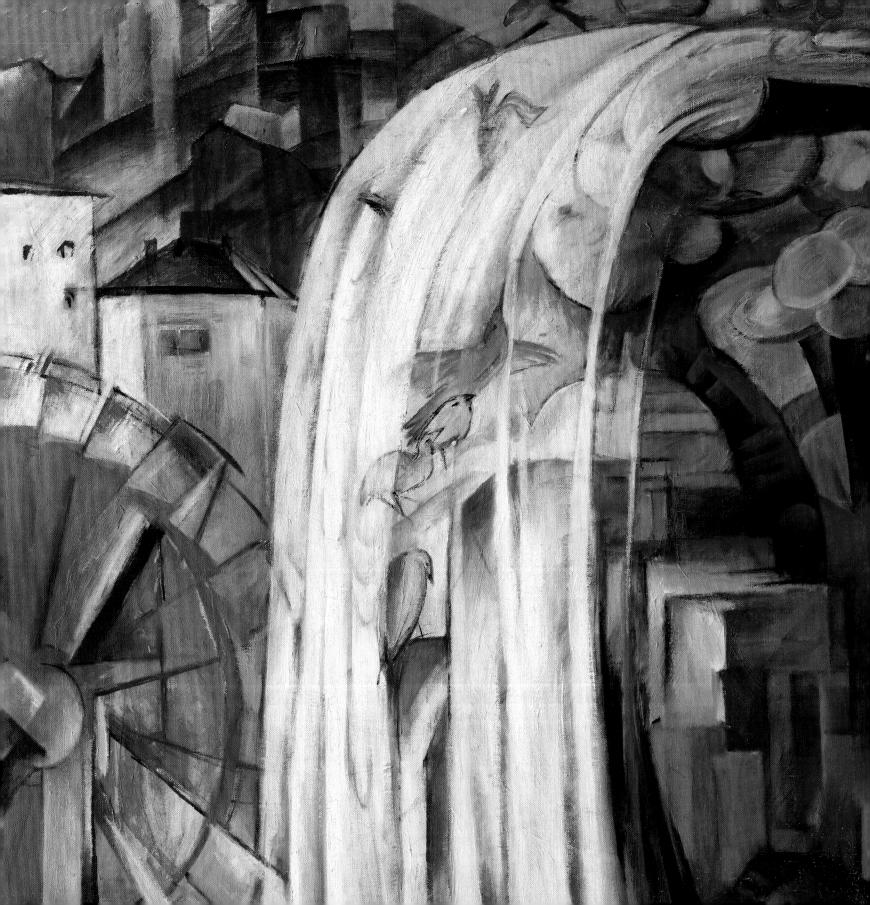

Expressionism

Expressionism refers to a general movement among artists working in Germany in the early twentieth century to utilize strong color and exaggerated form to express emotional, psychological, or spiritual content. Expressionists turned away from traditional academic art training in favor of working in small artist groups and, seeking pure expression, modeled their production on what they believed to be the undiluted power of non-Western objects and outsider art.

In 1905, a group of art students in Dresden's technical college—including Erich Heckel, Ernst Ludwig Kirchner, and Karl Schmidt-Rottluff—founded the first Expressionist group, Brücke (Bridge). Brücke's members shared a desire for a more direct, honest, and natural state of living and artmaking. Eventually joined by such like-minded artists as Emil Nolde and Max Pechstein, the young and revolutionary alliance aimed to create a "bridge" to a new future. The rough brushwork, jagged form, and vibrant, non-naturalistic color in works like Nolde's *Red-Haired Girl* (1919; p. 35) and Pechstein's *The Red House* (1911; p. 33) reflect the group's myriad influences—including the paintings of Vincent van Gogh and Edvard Munch, as well as African, Oceanic, and early German art—and their shared belief in the power of communal experiences in nature. By 1911, when the Brücke members relocated to Berlin, their work had influenced other artists who would later be grouped under the Expressionist banner, including the American expatriate Lyonel Feininger.

Around the same time that Brücke moved to Berlin, artists in Munich joined together as Blaue Reiter (Blue Rider). Although Brücke and Blaue Reiter shared a common interest in direct expression and the emotive qualities of color and form, members of Blaue Reiter, led by Vasily Kandinsky and Franz Marc, also looked to music as a significant source for inspiration. Marc was additionally interested in the direct experience of animals in nature. "Is there a more mysterious idea," he asked, "than to imagine how nature is reflected in the eyes of animals?" In *The Bewitched Mill* (1913; p. 31), Marc focused on the almost magical harmony between people, signified by the houses and mill on the left, and nature, embodied by the trees and animals on the right, an idea that had become apparent to him during a recent visit to the region of South Tyrol, near the border of Italy and Austria.

Many Expressionist groups disbanded with the onset of World War I, but as with the example of Max Herman Maxy (see p. 35), the interest in emotionally keyed color and form in art continued in Germany. Working in Berlin and other major German cities, artists like Max Beckmann increasingly took their inspiration from politics, modern society, and urban life, which they recorded with a critical and often sardonic eye. Although he did not identify himself as an Expressionist, Beckmann nevertheless utilized expressive formal qualities in his work and became one of the most acclaimed and successful German artists of the interwar period, until the rise of the Nazi Party made him a target of persecution. Beckmann's 1937 *Self-Portrait* (p. 37) demonstrates his use of bold color, angular form, and rough brushwork and presents an intense psychological portrayal of the artist and his complicated relationship to society. Indeed, shortly after completing this painting, Beckmann was forced to flee his homeland.

Detail of Franz Marc, *The Bewitched Mill* (1913; p. 31).

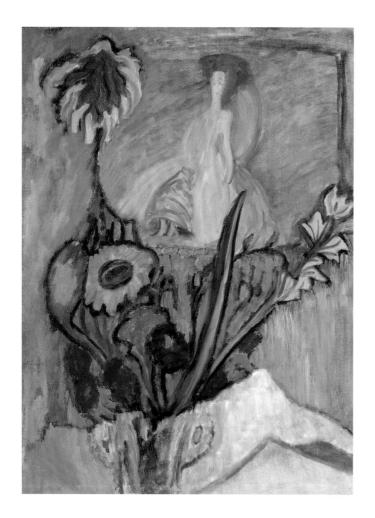

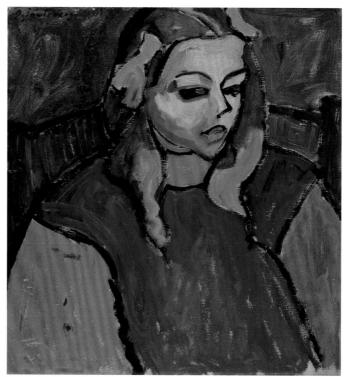

Gabriele Münter

German, 1877–1962

Still Life with Queen, 1912

Oil on canvas; 69.8 × 49 cm (27 7/16 × 19 5/16 in.)
Arthur Jerome Eddy Memorial Collection, 1931.521

Alexei Jawlensky

German, born Russia, 1864–1941

Girl with the Green Face, 1910

Oil on composition board; 53.1 × 49.2 cm (20 7/8 × 19 3/8 in.)
Gift of Mr. and Mrs. Earle Ludgin in memory of John V. McCarthy, 1953.336

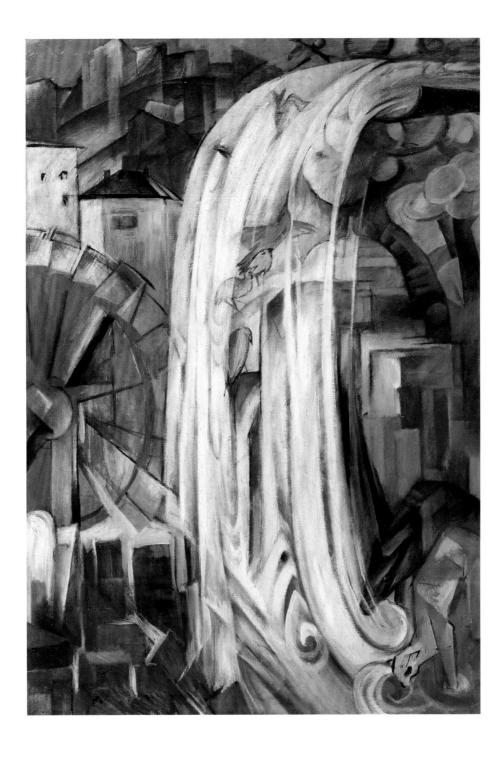

Franz Marc

German, 1880–1916

The Bewitched Mill, 1913

Oil on canvas; 129.9 × 90.6 cm (51 ³/₁₆ × 35 ¹¹/₁₆ in.)
Arthur Jerome Eddy Memorial Collection, 1931.522

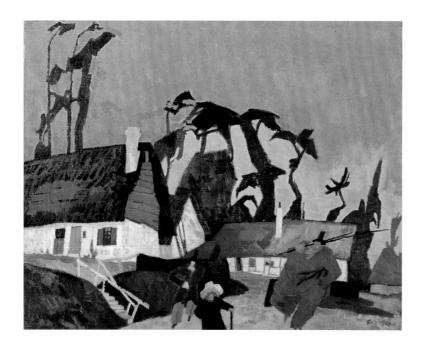

Lyonel Feininger

American, worked in Germany, 1871–1956

Longueuil, Normandie, October 1909

Oil on canvas; 80.2 × 100.5 cm (31 9/16 × 39 5/8 in.)
Gift of Clara Hoover Trust, 1998.357

Carnival in Arcueil, 1911

Oil on canvas; 105.4 × 95.8 cm (41 7/16 × 37 3/4 in.)
Joseph Winterbotham Collection, 1990.119

Max Pechstein

German, 1881–1955

The Red House, 1911

Oil on canvas; 80.5 × 70.9 cm (31 ¹¹⁄₁₆ × 27 ⅞ in.)
Bequest of Kenneth and Bernice Newberger, 2011.56

Karl Schmidt-Rottluff

German, 1884–1976

Two Girls in a Garden, 1914

Oil on canvas; 100.2 × 86.2 cm (39 ⁷⁄₁₆ × 33 ¹⁵⁄₁₆ in.)
Gift of Mr. and Mrs. Stanley M. Freehling in memory of Juliet S. Freehling, 1959.212

Max Herman Maxy

Romanian, 1895–1971

Cityscape, 1923

Oil on canvas; 68 × 78 cm (26 ¾ × 30 ¾ in.)
Through prior bequest of Mima de Manziarly Porter, 2013.58

Emil Nolde

German, 1867–1956

Red-Haired Girl, 1919

Oil on canvas; 65.2 × 39.2 cm (25 ⅛ × 15 ¹⁄₁₆ in.)
Bequest of Mr. and Mrs. George H. Tagge, 2002.589

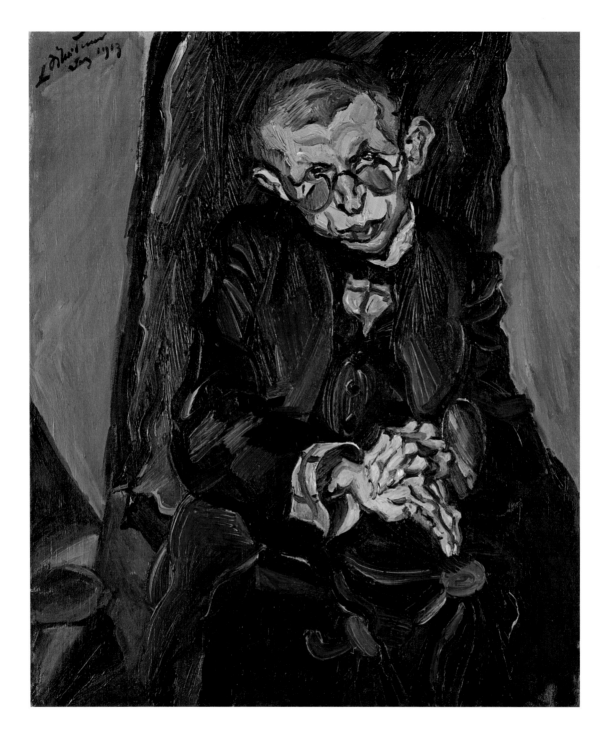

Ludwig Meidner

German, 1884–1966

Max Herrmann-Neisse, 1913

Oil on canvas; 89.5 × 75.6 cm (35 ¼ × 29 ¾ in.)
Gift of Mr. and Mrs. Harold X. Weinstein, 1959.215

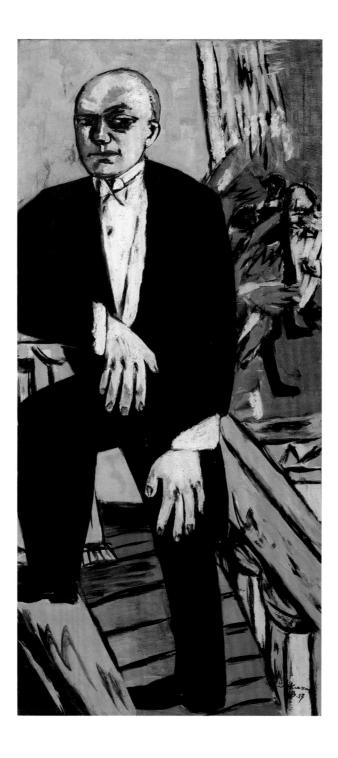

Max Beckmann

German, 1884–1950

Self-Portrait, 1937

Oil on canvas; 193.2 × 89.1 cm (76 ⅟₁₆ × 35 ⅟₁₆ in.)
Gift of Lotta Hess Ackerman and Philip E. Ringer, 1955.822

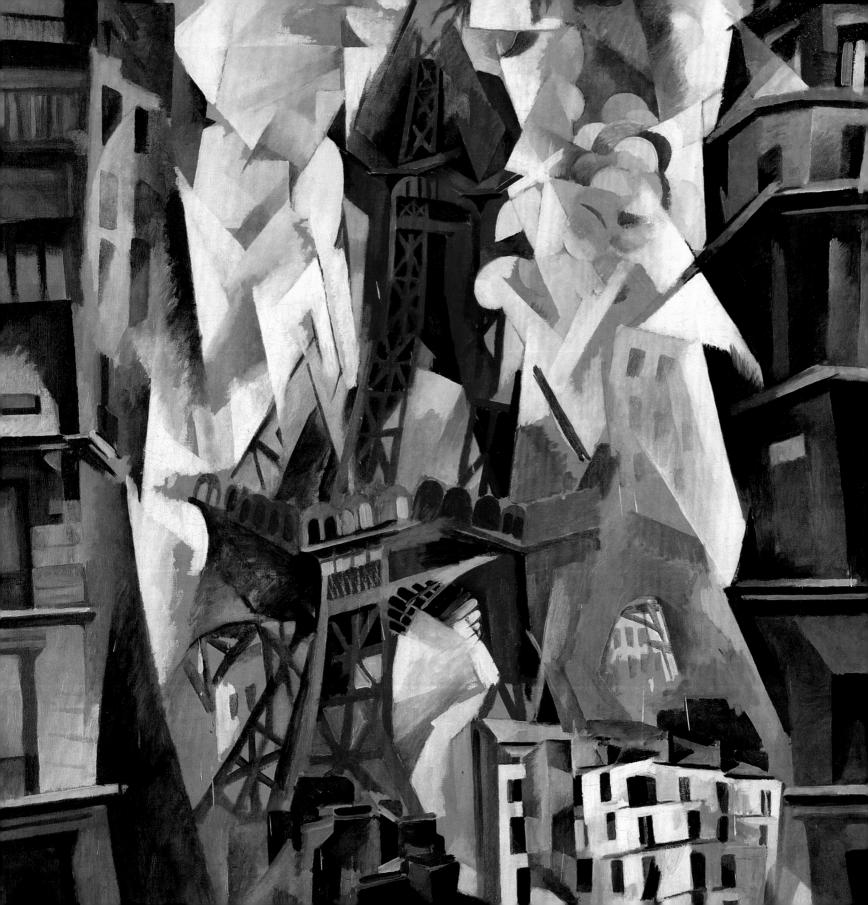

Cubism

While its revolutionary effect would be felt around the world, Cubism originated in the intimate collaboration and friendship of two painters, Georges Braque and Pablo Picasso. After meeting for the first time in 1907, Braque and Picasso would inspire and challenge each other for the next seven years, creating an artistic style that altered the way art was seen and made. Indeed, Braque once described their relationship during this period as that of "two mountain climbers roped together," a phrase that captures the spirit of adventure, peril, and interdependence the artists shared during the early development of Cubism.

Although markedly different in temperament and background, the two shared an interest in the faceted brushwork, shifting perspectives, and simplified forms of Paul Cézanne's canvases, an influence seen in one of Braque's earliest Cubist paintings, *Little Harbor in Normandy* (spring 1909; p. 40). Rather than reproducing a detailed description of the natural world, Braque and Picasso reduced their subjects to a series of geometric shapes, which they further broke down through fractured brushwork and evenly distributed tonal variation. As seen in *Little Harbor in Normandy*, the boundaries that normally divide foreground from background, sea from sky, or object from land lose their clarity and sometimes disappear altogether.

The first phase of Cubism, known as Analytic Cubism (named for the process of analyzing, dismantling, and reconfiguring a subject on canvas), explored line and form through simple, readily available subject matter, particularly still lifes and portraits of friends. Delicately overlapping planes in a severely reduced palette of black, browns, and grays replace the blocky shapes of the earliest canvases. In Picasso's image of the dealer and champion of Cubism, *Daniel-Henry Kahnweiler* (1910; p. 41), for example, these shifting shards hint at depth and shape, but never fully unite into a readily discernible image. Instead, Picasso selected a few signifiers—a lock of hair or a tie—to serve as clues to his subject's identity.

Beginning in 1912 and 1913, Picasso and Braque began working with collage and papier collé, which subsequently ushered in a new phase of Cubism. Up to this point, pictures had provided illusionistic spaces for viewers to enter via their imaginations. The presence of real objects (bits of newspaper or wallpaper, for example) on the surface of the canvas shattered this tradition of illusionism and instead emphasized the fact that the canvas existed in real space. It also offered new forms of representation, in which fragments of images, objects, or words function as signs to represent a subject. Such discoveries led to Synthetic Cubism, in which the image was fully constructed out of signs and multiple modes of representation were employed in a single composition. Juan Gris's *Abstraction (Guitar and Glass)* (1913; p. 44) is such a work, with its flattened, clearly defined forms, saturated color, trompe l'oeil, and rhythmic patterning of overlapping planes. While Synthetic Cubism marked the last stage of Picasso and Braque's partnership, their revolutionary innovations had already been adopted by other artists, in Paris and abroad, who saw in their works emblems of the speed and vitality of the modern world. Indeed, Robert Delaunay and Jacques Lipchitz, among other artists, would continue to develop Cubist language for their own diverse purposes in the years to come.

Detail of Robert Delaunay, *Champs de Mars: The Red Tower* (1911/23; p. 45).

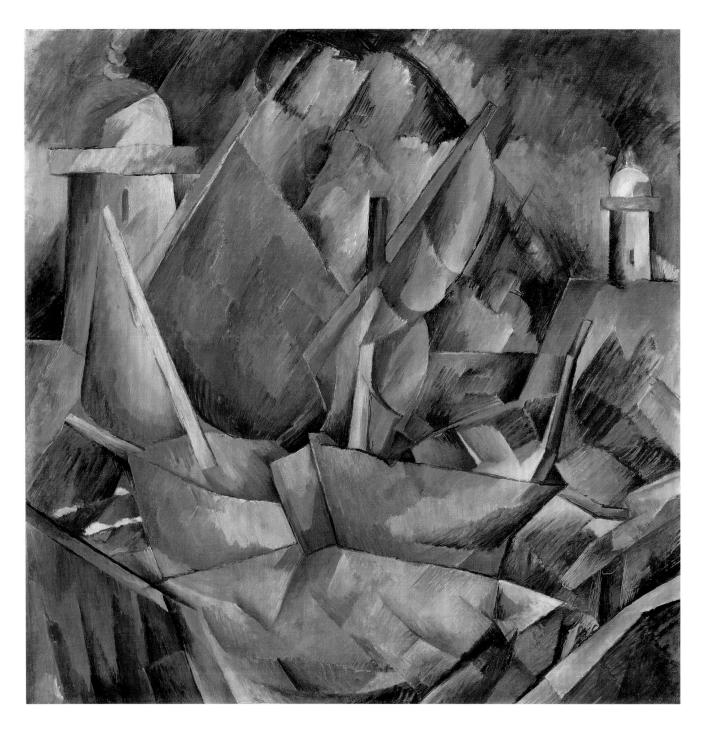

Georges Braque

French, 1882–1963

Little Harbor in Normandy, spring 1909

Oil on canvas; 81.4 × 81.1 cm (32 ⅟₁₆ × 32 in.)
Samuel A. Marx Purchase Fund, 1970.98

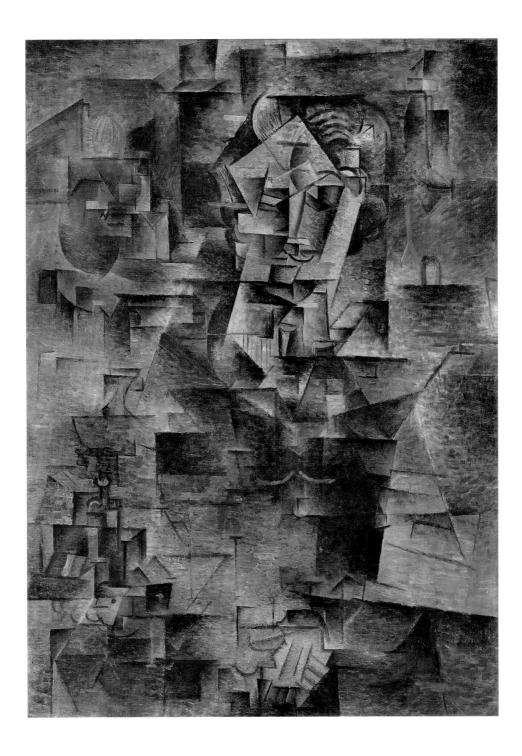

Pablo Picasso

Spanish, worked in France, 1881–1973

Daniel-Henry Kahnweiler, fall 1910

Oil on canvas; 100.4 × 72.4 cm (39 9/16 × 28 9/16 in.)
Gift of Mrs. Gilbert W. Chapman in memory of Charles B. Goodspeed, 1948.561

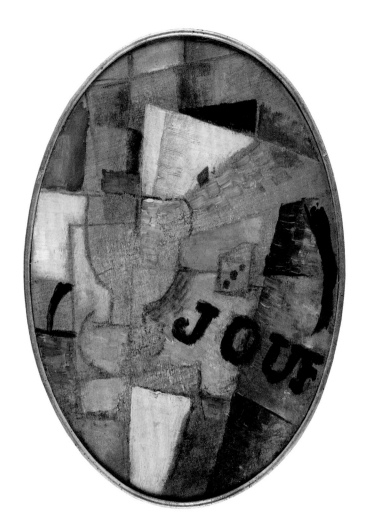

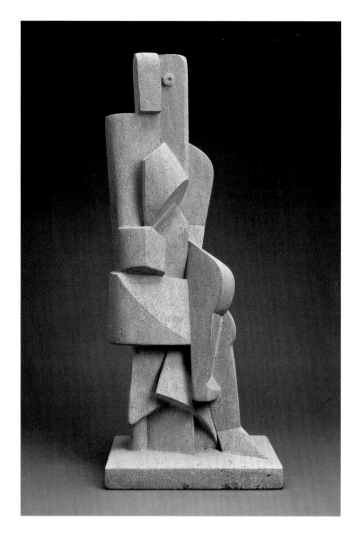

Georges Braque

French, 1882–1963

Still Life with Glass, Dice, Newspaper and Playing Card, 1913

Oil on canvas mounted on hardboard; 34.7 × 24 cm (13 ⅝ × 9 ⁷⁄₁₆ in.)
Bequest of Mima de Manziarly Porter, 1989.51.1

Jacques Lipchitz

American, born Lithuania, 1891–1973

Seated Figure, 1917

Limestone; 86.6 × 37 × 29.8 cm (34 ¹⁄₁₆ × 14 ⁹⁄₁₆ × 11 ¾ in.)
Robert A. Waller Fund, 1960.351

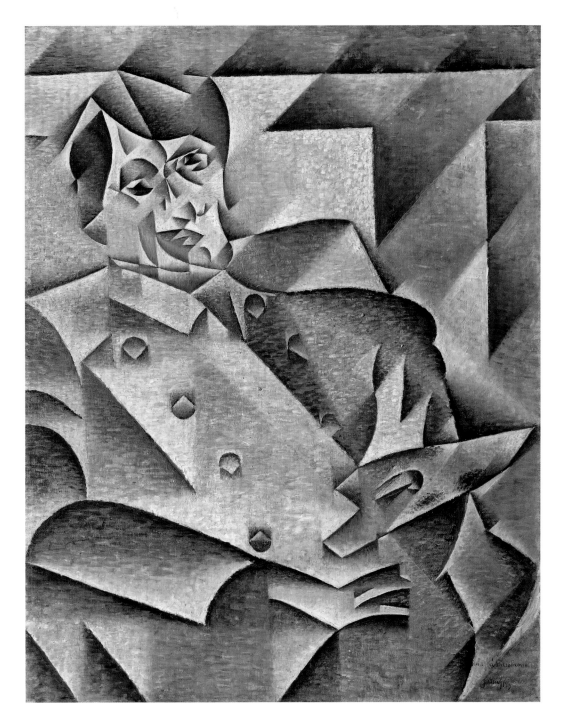

Juan Gris

Spanish, 1887–1927

Portrait of Pablo Picasso, January–February 1912

Oil on canvas; 93.5 × 74.3 cm (36 ¹³⁄₁₆ × 29 ¼ in.)
Gift of Leigh B. Block, 1958.525

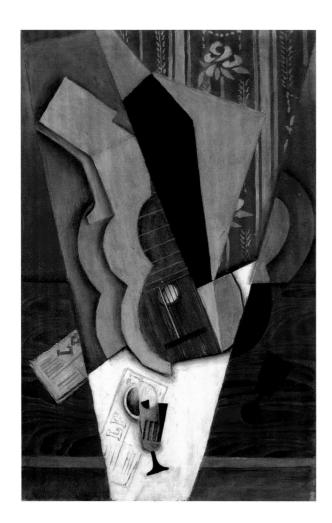

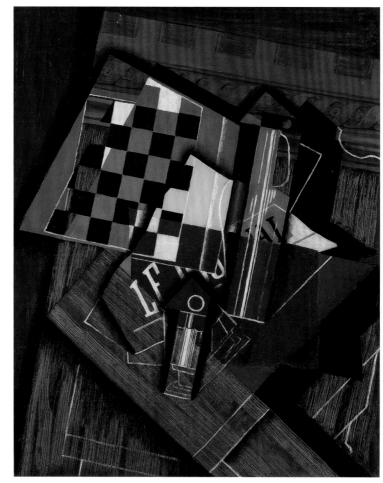

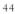44

Juan Gris

Spanish, 1887–1927

Abstraction (Guitar and Glass), July 1913

Oil on canvas; 91.5 × 59.7 cm (36 × 23 ½ in.)
Charles H. and Mary F. S. Worcester Fund, 1961.36

The Checkerboard, September 1915

Oil on canvas; 92.2 × 73.1 cm (36 ¼ × 28 ¾ in.)
Ada Turnbull Hertle Endowment; gift of Mrs. Leigh B. Block, 1956.16

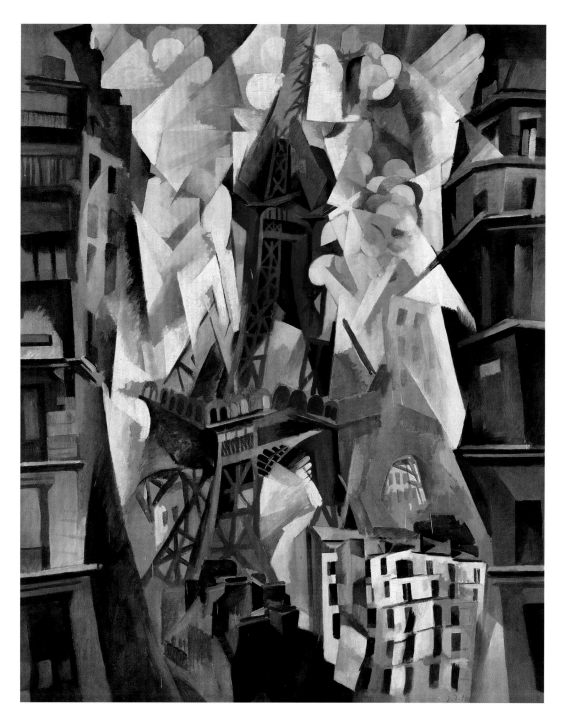

Robert Delaunay

French, 1885–1941

Champs de Mars: The Red Tower, 1911/23

Oil on canvas; 163 × 130.3 cm (64 ⁷⁄₁₆ × 51 ⁵⁄₁₆ in.)
Joseph Winterbotham Collection, 1959.1

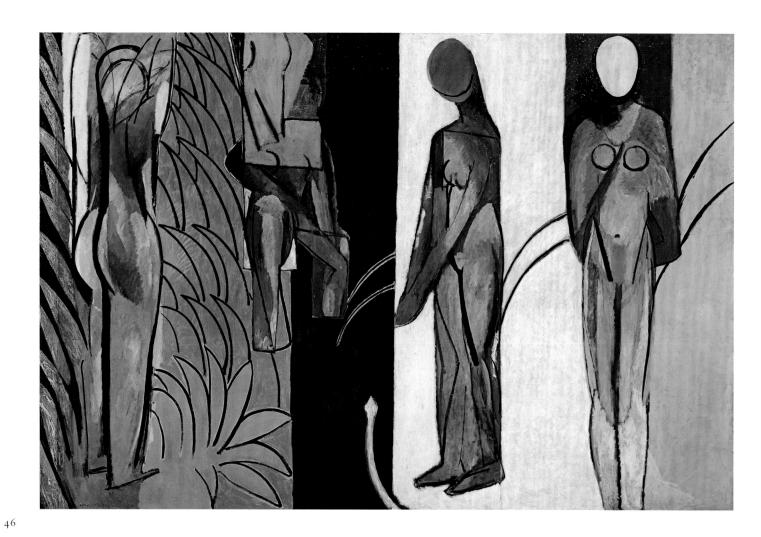

46

Henri Matisse

French, 1869–1954

Bathers by a River, March 1909–10, May–November 1913, and early spring 1916–October (?) 1917

Oil on canvas; 260 × 392 cm (102 ½ × 154 ³⁄₁₆ in.)
Charles H. and Mary F. S. Worcester Collection, 1953.158

Georges Braque

French, 1882–1963

Woman at an Easel (Green Screen), 1936

Oil on canvas; 92 × 73 cm (36 ¼ × 28 ¾ in.)
A Millennium Gift of Sara Lee Corporation, 1999.367

Still Life with Fruits and Stringed Instrument, 1938

Oil on canvas; 114.3 × 145.5 cm (45 × 58 in.)
Gift of Mary and Leigh Block, 1988.141.6

Marc Chagall

Although Marc Chagall always identified himself with the place of his birth, Vitebsk, Russia (present-day Belarus), he spent much of his life abroad, particularly in France. As a result, his work exhibits a unique blend of personal, folkloric, and almost magical subject matter infused with international avant-garde styles.

During his first extended period in Paris, from 1910 to 1914, Chagall lived and worked in La Ruche (The Hive), an artists' residence also inhabited at one time or another by Constantin Brâncusi, Robert Delaunay, Max Jacob, Fernand Léger, Jacques Lipchitz, Amedeo Modigliani, and Chaim Soutine. Referring to the impoverished, squalid, and cramped quarters that nonetheless teemed with artistic talent, Chagall once stated that in La Ruche, "you either came out dead or famous." Within this hotbed of creativity, Chagall's style developed quickly: works from this period demonstrate aspects of both Cubism and Expressionism in their fractured forms and vibrant colors, as seen in *Birth* (1911/12; p. 50), which was based on his memory of the birth of his brother. His canvases caught the attention of critics and collectors alike; Herwarth Walden, one of Berlin's most influential dealers and a champion of Expressionism, offered to show Chagall's paintings in the 1913 *Erster Deutscher Herbstsalon (First German Autumn Salon)* as well as in exhibitions at his influential Galerie Der Sturm (Storm Gallery), including a retrospective for the young artist in the summer of 1914.

It was around the time of the 1914 exhibition that Chagall traveled from Berlin to Vitebsk, after which he intended to return to Paris. However, the outbreak of World War I in August forced him to alter his plans, and he would spend the next eight years in Russia. While in Vitebsk, Chagall became concerned with documenting the disappearing cultural and social "types" within the newly modernizing society of his homeland. For *The Praying Jew* (1923, one of two versions after a 1914 composition; p. 50), he paid a passing beggar to pose in his father's prayer clothes. The painting's stark palette of black and white underscores its serious subject matter. After the Bolshevik Revolution, Chagall became Commissar for the Arts in Vitebsk and subsequently founded an art school and museum. His popularity and position were short-lived, however, and in 1922 he left Russia, returning to Paris in 1923.

Chagall's Russian-Jewish heritage was always central to his work, but the nature of its role varied over time. Reacting to the rise of Nazism in Germany, he invested the religious symbolism of his paintings with contemporary social commentary. *White Crucifixion* (1938; p. 51) was the first of a series of compositions featuring the image of Christ as a Jewish martyr. Painted in the same year as the infamous Kristallnacht, the painting emphasizes Jesus's Jewish identity by depicting him in traditional clothing and surrounding the image of his suffering with representations of pogroms. Originally, Chagall painted the soldiers wearing armbands with swastikas, but he later painted over the Nazi symbols. By relating contemporary events to the martyrdom of Christ, Chagall united Christian and Jewish allegories; removing the swastikas released the painting from its specific historical context and allowed it to take on more universal significance.

49

Chagall with his wife Bella and daughter Ida before *The Praying Jew* (p. 50) in their Paris apartment, c. 1923.

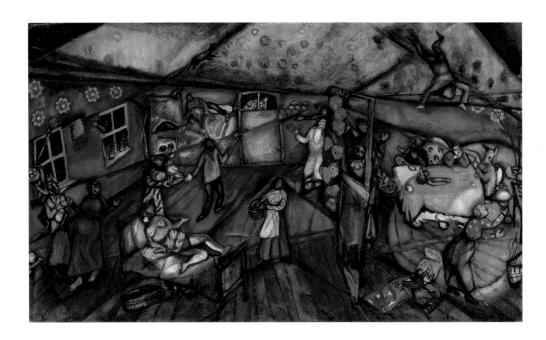

Marc Chagall

French, born Vitebsk, Russia (present-day Belarus), 1887–1985

Birth, 1911/12

Oil on canvas; 114 × 195.2 cm (44 ⅞ × 76 ¾ in.)
Gift of Mr. and Mrs. Maurice E. Culberg, 1952.3

The Praying Jew, 1923 (one of two versions after a 1914 composition)

Oil on canvas; 116.3 × 89.3 cm (45 ¾ × 35 ³⁄₁₆ in.)
Joseph Winterbotham Collection, 1937.188

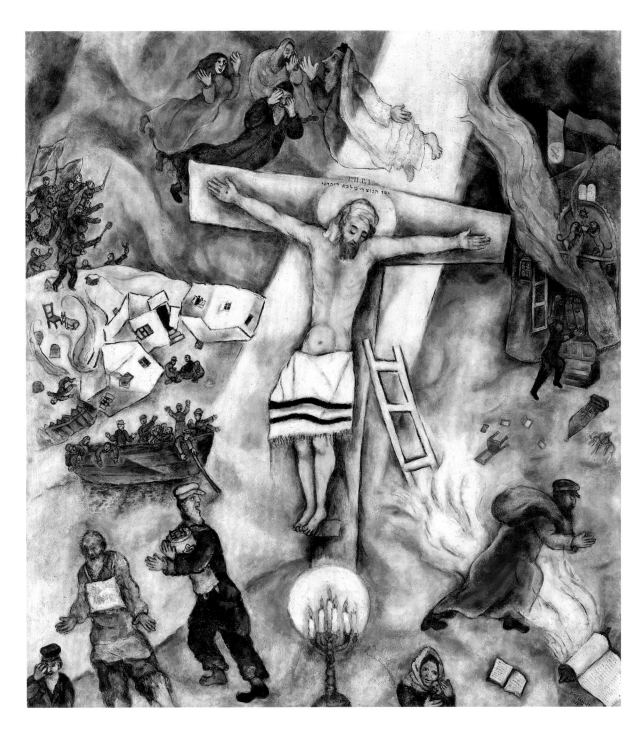

Marc Chagall

French, born Vitebsk, Russia (present-day Belarus), 1887–1985

White Crucifixion, 1938

Oil on canvas; 154.6 × 140 cm (60 ⅞ × 55 ⅟₁₆ in.)
Gift of Alfred S. Alschuler, 1946.925

Pablo Picasso

Pablo Picasso was the twentieth century's most prolific artist, equally as innovative in painting as in sculpting, drawing, and printmaking. While he was integral to the development of Cubism, among other styles, his true skill lay in his ability to work in a variety of modes and media, depending on what the subject demanded; at the same time, his nearly eighty-year career demonstrates remarkable consistency in its series of enduring themes. Within all this, his apparently inexhaustible output closely corresponded to his personal life and the muses who inspired his work.

Fernande Olivier was the artist's first great love, and the couple lived together from 1905 until 1912. She served as a model for many of his Rose Period and Cubist works, including his only sculpture from the first phase of Cubism, the revolutionary *Head of a Woman (Fernande)* (1909; p. 54). With its lively play of concave and convex, repeated and rhythmic forms, the sculpture was a major advance in Picasso's development of Cubism in three dimensions.

Like many artists in the years after World War I, a period known as "the return to order," Picasso balanced his interest in the fragmented forms of Cubism with his development of a kind of modern classicism. Having traveled to Rome in 1917 to design sets and costumes for Sergei Diaghilev's Ballets Russes, he was impressed by the city's ancient and Renaissance art. He also returned to the theme of maternity, a subject he had last investigated nearly fifteen years earlier that was newly informed by his marriage to Russian ballerina Olga Khokhlova and the birth of their son, Paulo. Picasso now focused on monumental figures, such as those in *Mother and Child* (1921; p. 56), with their healthy, rounded solidity accentuated by classical costumes.

In the late 1920s, the artist's focus shifted again, inspired in part by his involvement with the Surrealists and by the creative vitality he felt with his new muse, the young Marie-Thérèse Walter (see p. 58). His work during this time often took on a strongly metamorphic and experimental quality, as exemplified in paintings like *Head* (1927; p. 59). Here Picasso conflated the female body with a human head in order to create the amorphous and vaguely threatening form at the center of the composition, made all the more strange by his use of powdered pigment sprinkled unevenly across the surface. Painted a few years later, *Abstraction: Background with Blue Cloudy Sky* (1930; p. 60) features a nightmarish figure at its center that possesses many of the same characteristics as *Head* but goes still further by infusing the woman's bust with aspects of insects and stone.

Picasso's later career saw a revival of his interest in classicism, as well as a renewed focus on the work of the Old Masters. In *Nude under a Pine Tree* (1959; p. 61), he evoked the seductive female nude of Francisco de Goya's *Nude Maja* (1797–1800, Museo del Prado, Madrid). Rejecting the plush surroundings in Goya's picture, however, Picasso placed his massive figure in the outdoors, her faceted form mirroring the surrounding rocky terrain. Painted in the south of France, where Picasso lived with his second wife, Jacqueline Roque, the massive canvas is as much an ode to Cézanne as to Goya, and even a recognition of his thoughts about his own place within the history of art.

Picasso at his home, La Californie, surrounded by recent paintings and *Nude under a Pine Tree* (p. 61), 1960.

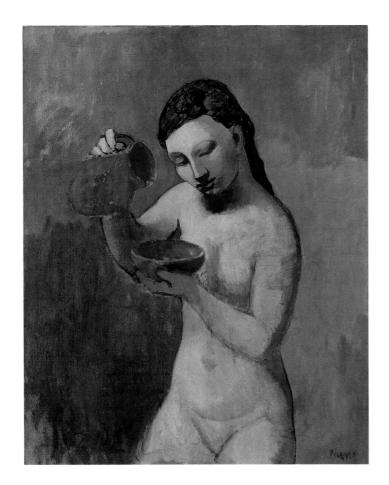

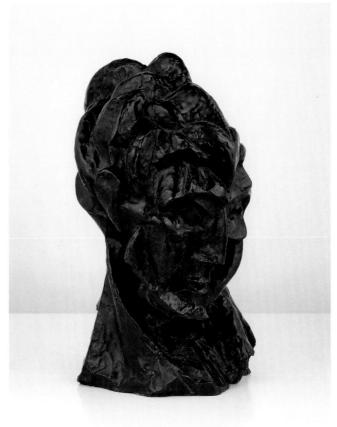

Pablo Picasso

Spanish, worked in France, 1881–1973

Nude with a Pitcher, summer 1906

Oil on canvas; 100.6 × 81 cm (39 ⅝ × 31 ⅞ in.)
Gift of Mary and Leigh Block, 1981.14

Head of a Woman (Fernande), fall 1909

Bronze; 40.7 × 20.1 × 26.9 cm (16 ⅛ × 9 ⅞ × 10 ⁹⁄₁₆ in.)
Alfred Stieglitz Collection, 1949.584

Pablo Picasso

Spanish, worked in France, 1881–1973

Man with a Pipe (Man with a Mustache, Buttoned Vest, and Pipe), 1915

Oil on canvas; 129.8 × 88.5 cm (51 ¹⁄₁₆ × 34 ¹³⁄₁₆ in.)
Gift of Mrs. Leigh B. Block in memory of Albert D. Lasker, 1952.1116

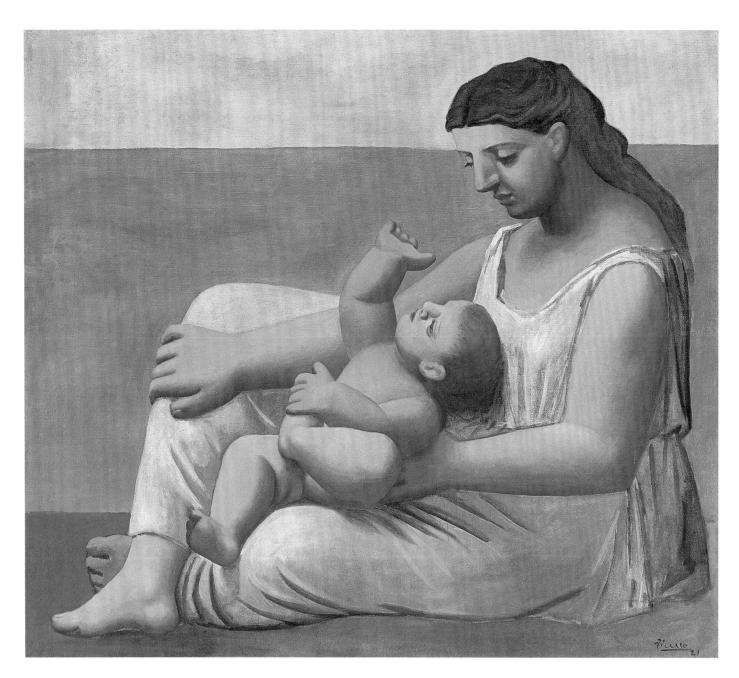

56

Pablo Picasso

Spanish, worked in France, 1881–1973

Mother and Child, 1921

Oil on canvas; 142.9 × 172.7 cm (56 ¼ × 68 in.)
Restricted gift of Maymar Corporation, Mrs. Maurice L. Rothschild, and Mr. and Mrs. Chauncey
McCormick; Mary and Leigh Block Fund; Ada Turnbull Hertle Endowment; through prior gift of
Mr. and Mrs. Edwin E. Hokin, 1954.270

Pablo Picasso

Spanish, worked in France, 1881–1973

Still Life, February 4, 1922

Oil on canvas; 81.6 × 100.3 cm (32 ⅛ × 39 ⅝ in.)
Ada Turnbull Hertle Endowment, 1953.28

58

Pablo Picasso

Spanish, worked in France, 1881–1973

The Red Armchair, December 16, 1931

Oil and Ripolin on panel; 131.1 × 98.7 cm (51 ⅝ × 38 ⅞ in.)
Gift of Mr. and Mrs. Daniel Saidenberg, 1957.72

Pablo Picasso

Spanish, worked in France, 1881–1973

Head, 1927

Oil and chalk on canvas; 99.5 × 80.7 cm (39 ⅜ × 31 ¾ in.)
Gift of Florene May Schoenborn and Samuel A. Marx, 1951.185

60

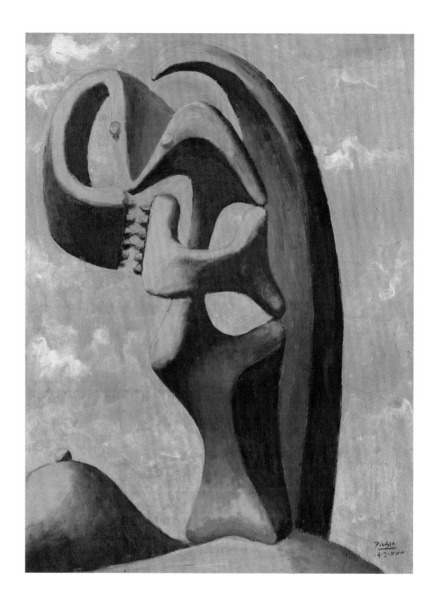

Pablo Picasso

Spanish, worked in France, 1881–1973

Figure, 1935

Wood, metal, plastic, nails, screws, paint, twine, paper, and concrete; 63.5 × 18 × 13.7 cm
(24 ¾ × 7 ¼ × 5 ½ in.)
Mary L. and Leigh B. Block, Alyce and Edwin DeCosta, and the Walter E. Heller
Foundation endowments; through prior gifts of Mary L. and Leigh B. Block, 1988.428

Abstraction: Background with Blue Cloudy Sky, January 4, 1930

Oil on panel; 66 × 49.1 cm (26 × 19 ¼ in.)
Gift of Florene May Schoenborn and Samuel A. Marx; Wilson L. Mead Fund, 1955.748

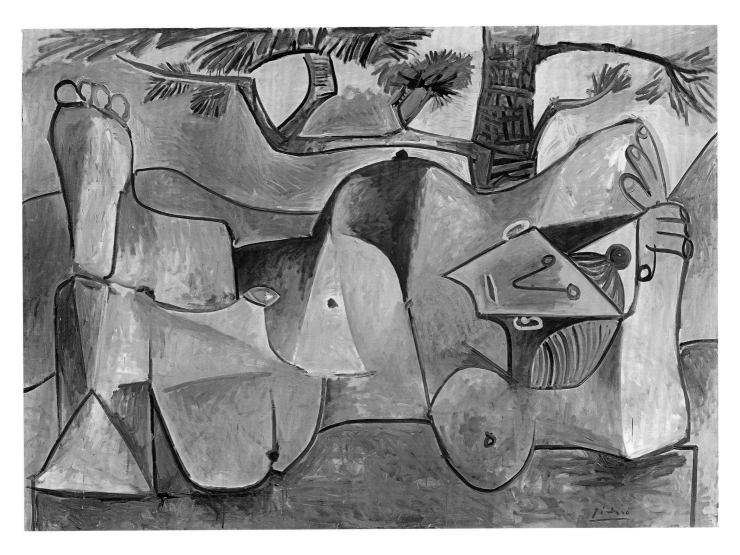

Pablo Picasso

Spanish, worked in France, 1881–1973

Nude under a Pine Tree, January 20, 1959

Oil on canvas; 194 × 279.5 cm (76 3/8 × 110 1/8 in.)
Bequest of Grant J. Pick, 1965.687

School of Paris

Although numerous cities had thriving artistic communities, Paris remained Europe's undisputed cultural center in the early twentieth century. Critical to this dynamic was the increasingly international character of artists living in the neighborhoods of Montmartre and Montparnasse, areas that were especially important quarters for individuals of Jewish and Eastern European origins, including Marc Chagall, Jacques Lipchitz, and Chaim Soutine. The intimate double portrait of *Jacques and Berthe Lipchitz* (1916; p. 69) by the Italian Amedeo Modigliani reflects the close personal and professional relationships that were forged between the diverse individuals who populated Paris at the time. Out of this crucible of internationalism and creative activity, artists drew upon the emerging styles of Fauvism, Expressionism, and Cubism, the non-Western objects that appeared in the city's flea markets and ethnographic museum, and their own personal and cultural interests.

Among the newcomers to Paris was Gino Severini, who left Italy and his fellow Futurists—a group of young artists who advocated the destruction of the past by celebrating the speed of modern industrial culture—for the glittering cosmopolitanism of the French city. For *Festival in Montmartre* (1913; p. 64), Severini applied the Futurists' unique blend of Cubism's fractured forms and Divisionism's dynamic points of color to capture the centrifugal motion of a carousel and the bright, joyful chaos of the surrounding festival.

While Severini celebrated the city's pulsating urban nightlife, it is perhaps indicative of the open artistic culture in Paris at this time that the work of another of his compatriots, Giorgio de Chirico, reveals a completely different character. Often set in nearly empty plazas with classical arcades and morden urban elements (such as a train), de Chirico's metaphysical landscapes exhibit an eerie calm that differs markedly from *Festival in Montmartre*'s whirling, brightly colored fragments. In *The Philosopher's Conquest* (1913–14; p. 65), subtly illogical spatial constructions contrast with the artist's stark, matter-of-fact style, enhancing the picture's overall sense of disquiet and contributing a dreamlike quality that would inspire the Surrealists in the following decade.

For some artists, moving to Paris meant a change not only in culture but also in vocation. Julio González initially worked in his native Barcelona as a metalsmith but traveled to Paris to pursue a career in painting. There he came to know Pablo Picasso, with whom he eventually embarked on a group of landmark metal sculptures. Rather than carving in stone or modeling in plaster, González welded together pieces of iron geometrically cut to construct his subjects, including *Woman with Hair in a Bun* (c. 1930; p. 71).

With its well-established, complex, and thriving artistic community, Paris maintained its place of preeminence until the onset of World War II, when many of the city's artistic leaders fled the continent or returned to their native countries, often for good. This renewed dispersal of artistic talent led, in turn, to the rise of new centers of cultural activity after the war, particularly New York.

63

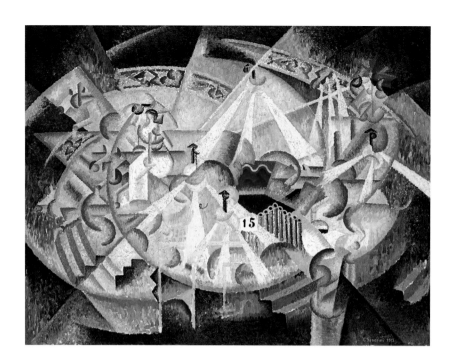

Gino Severini

Italian, 1883–1966

Festival in Montmartre, 1913

Oil on canvas; 88.7 × 115.7 cm (34 ⅞ × 45 ⁹⁄₁₆ in.)
Bequest of Richard S. Zeisler, 2007.281

Still Life (Centrifugal Expansion of Colors), 1916

Oil on canvas; 65.7 × 60.9 cm (25 ⅞ × 23 ⅞ in.)
Alfred Stieglitz Collection, 1949.581

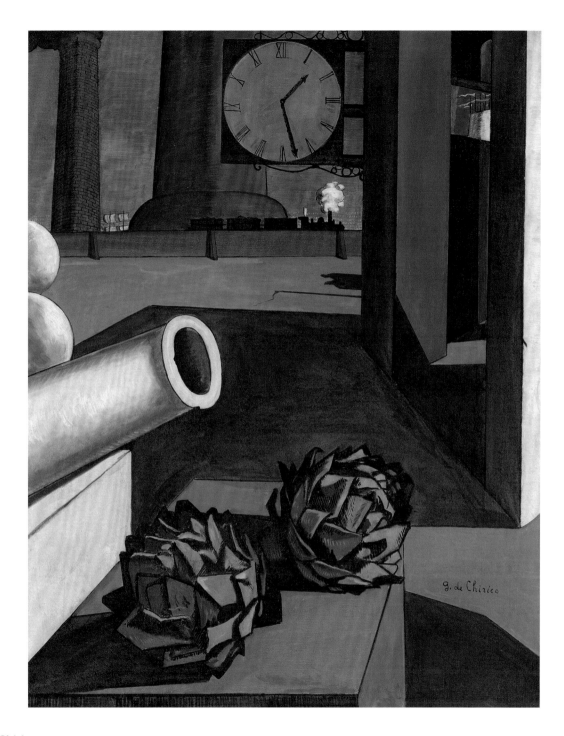

Giorgio de Chirico

Italian, born Greece, 1888–1978

The Philosopher's Conquest, late 1913–early 1914

Oil on canvas; 126.3 × 99.3 cm (49 ¹¹⁄₁₆ × 39 ½ in.)
Joseph Winterbotham Collection, 1939.405

Nathalija Gontcharova

Russian, 1881–1962

Spanish Dancer, c. 1916

Oil on canvas; 200.2 × 89.2 cm (78 ⅞ × 35 ⅛ in.)
Gift of Mrs. Patrick C. Hill in memory of her mother, Rue Winterbotham Carpenter, 1971.777

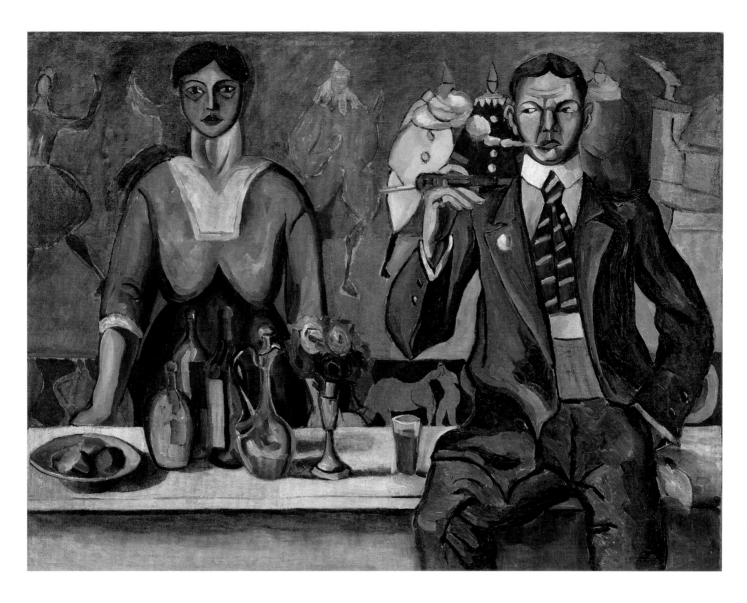

Aleksei Alekseevich Morgunov

Russian, 1884–1935

Portrait of Nathalija Gontcharova and Mihajl Larionov, 1913

Oil on canvas; 96.4 × 129.7 cm (37 ⁵⁄₁₆ × 51 ¹⁄₁₆ in.)
Mary and Leigh Block Fund for Acquisitions, 1975.666

Joan Miró

Spanish, 1893–1983

Portrait of Juanita Obrador, 1918

Oil on canvas; 69.6 × 61.9 cm (27 ⅝ × 24 ³⁄₁₆ in.)
Joseph Winterbotham Collection, 1957.78

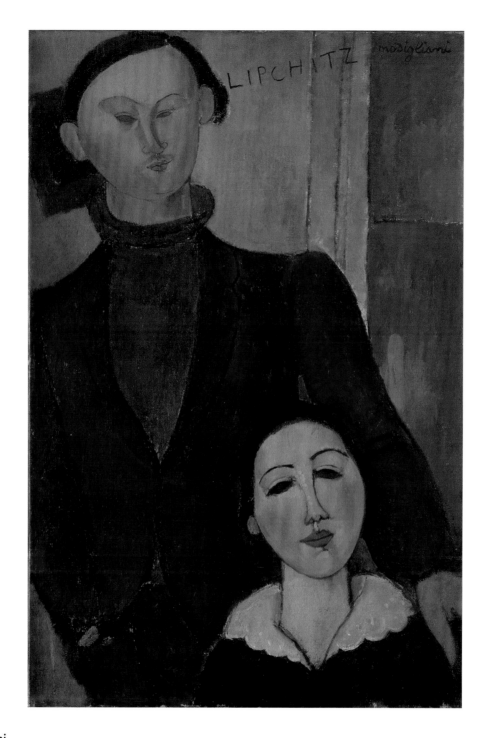

Amedeo Modigliani

Italian, 1884–1920

Jacques and Berthe Lipchitz, 1916

Oil on canvas; 81 × 54.2 cm (31 ⅞ × 21 ⁵⁄₁₆ in.)
Helen Birch Bartlett Memorial Collection, 1926.221

Giorgio de Chirico

Italian, born Greece, 1888–1978

The Eventuality of Destiny, 1927

Oil on canvas; 146.5 × 114.6 cm (57 ⅝ × 45 ¹⁄₁₆ in.)
Gift of Mrs. Frederic Clay Bartlett, 1964.213

Julio González

Spanish, 1876–1942

Woman with Hair in a Bun, c. 1930

Iron on stone base; 54.9 × 23.2 × 23.3 cm (12 ⅝ × 9 ⅛ × 9 ³⁄₁₆ in.)
Ada Turnbull Hertle, Laura R. Magnuson, Samuel A. Marx, and
Morris L. Parker funds, 1981.648

Chaim Soutine

Lithuanian, 1883–1943

Dead Fowl, 1926

Oil on canvas; 97.5 × 63.3 cm (38 ⅜ × 24 ⅞ in.)
Joseph Winterbotham Collection, 1937.167

Henri Matisse

Henri Matisse looms like a benevolent giant over the history of twentieth century art; few if any other artists could claim to be as influential to their peers and the generations that followed. Yet Matisse discovered his love of painting relatively late in life, when he fell ill while working as a law clerk in northern France. Returning to Paris, he immersed himself in the study of painting and soon emerged as a leader among his peers. He went on to become not only modernism's ceaseless champion of color but also one of the most inventive artists in history.

Like many artists working in the first half of the twentieth century, Matisse was inspired by the arts of non-Western cultures. Unlike his contemporaries, however, who were preoccupied with the perceived formal purity of primitive art, he was more intrigued by the richly patterned art and textiles of Islamic cultures, as well as the light and color he saw during his travels in Algeria and Morocco. The influence of these sources is evident in the paintings he produced in Nice, where the diffuse light of southern France resembled the luminescence he found abroad. He had come under the spell of Mediterranean light as early as 1904, when, following the examples of Paul Signac and Paul Cézanne, he painted some of his first Fauve pictures in the French fishing town of Collioure. Although the turbulence of World War I was accompanied by stark, imposing experiments with abstract form, most notably *Bathers by a River* (1909–10, 1913, and 1916–17; p. 46), Matisse soon resumed his exploration of the effects of the southern coast's warm light. From 1917 onward, he spent much of his time in the south of France, where he painted models in elaborate interiors. Paintings like *Interior at Nice* (1919 or 1920; p. 76) not only reflect

the bright warmth of the Mediterranean but also draw from the intricate, decorative patterns of objects, especially textiles, he acquired in northern Africa. In some cases, he incorporated representations of the objects themselves into his pictures, as seen in the patterned screen in the background of *Woman before an Aquarium* (1921–23; p. 75). Other Matisse compositions of this period exhibit a more general delight in the busy, yet flattening effect of patterning.

While the models of Matisse's Nice period typically appear to be part of their surroundings, unified through their mutual subordination to the light suffusing his interiors, by the mid-1920s his female subjects increasingly gained crispness and solidity, as well as a greater autonomy from their environments. This interest in the physicality of his painted figures paralleled Matisse's return to sculpture. While in Nice he studied a copy of Michelangelo's *Night* (original 1521–34) at the École des Arts Décoratifs, exploring the figure in drawings, lithographs, and sculpture in order to understand, as he put it, "the clear and complex construction of Michelangelo." Among the most notable of these efforts is the bronze *Seated Nude* (1925–29; p. 77). Working over several years, Matisse gradually increased the size of the figure and dramatically cantilevered its pose, making it his largest freestanding sculpture.

Matisse at work in his Issy-les-Moulineaux studio with *Bathers by a River* (p. 46), May 13, 1913.

Henri Matisse

French, 1869–1954

Apples, 1916

Oil on canvas; 116.5 × 89.5 cm (45 ¹³⁄₁₆ × 35 ¼ in.)
Gift of Florene May Schoenborn and Samuel A. Marx, 1948.563

Henri Matisse

French, 1869–1954

Woman before an Aquarium, 1921–23

Oil on canvas; 81 × 100.3 cm (31 ¹⁵⁄₁₆ × 39 ½ in.)
Helen Birch Bartlett Memorial Collection, 1926.220

Henri Matisse

French, 1869–1954

Interior at Nice, 1919 or 1920

Oil on canvas; 131.3 × 90.4 cm (51 ¾ × 35 ⅝ in.)
Gift of Mrs. Gilbert W. Chapman, 1956.339

Henri Matisse

French, 1869–1954

Lorette with Cup of Coffee, 1916–17

Oil on canvas; 57.6 × 39.7 cm (22 ⅝ × 15 ⅝ in.)
Estate of Marguerita S. Ritman; Marion and Samuel Klasstorner
Endowment; through prior gifts of Philip D. Armour; through
prior bequests of Dorothy C. Morris and Marguerita S. Ritman,
1993.186

Seated Nude, 1925–29

Bronze; 78.8 × 79 × 34.5 cm (31 ¹/₁₆ × 31 ⅛ × 13 ⁹/₁₆ in.)
Ada Turnbull Hertle Fund, 1958.16

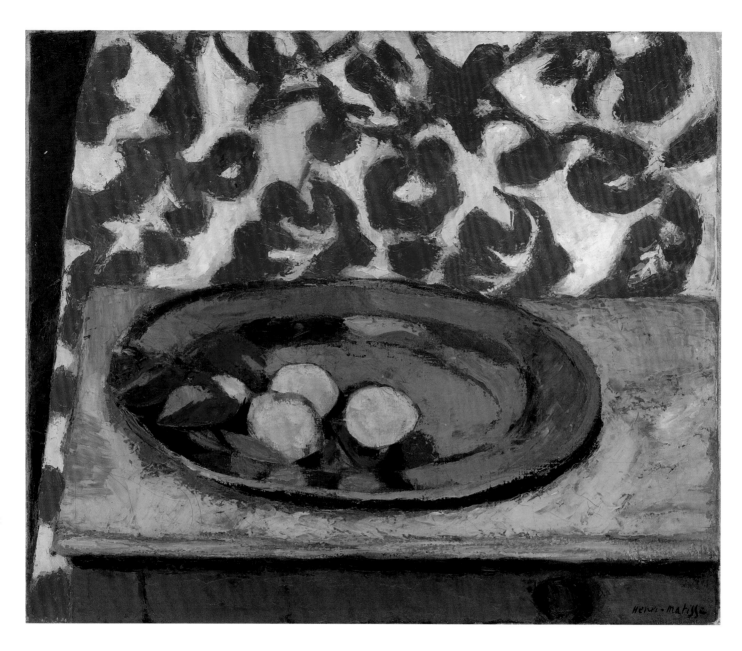

78

Henri Matisse

French, 1869–1954

Lemons on a Pewter Plate, 1926 (reworked in 1929)

Oil on canvas; 54.7 × 65.9 cm (21 9/16 × 25 15/16 in.)
A Millennium Gift of Sara Lee Corporation, 1999.371

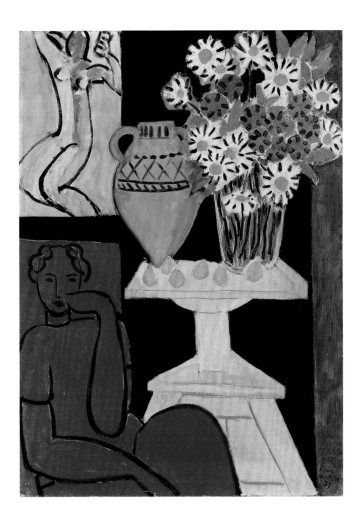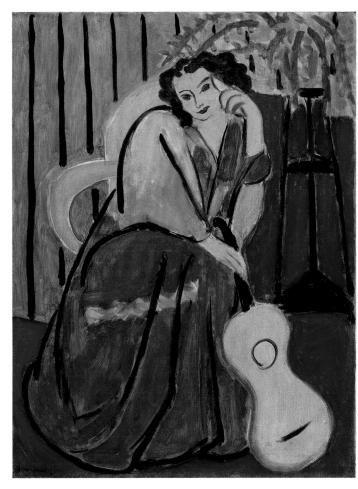

Henri Matisse

French, 1869–1954

Daisies, July 16, 1939

Oil on canvas; 92 × 65.1 cm (36 ¼ × 25 ⅝ in.)
Gift of Helen Pauling Donnelley in memory of her parents,
Mary Fredericka and Edward George Pauling, 1983.206

Girl in Yellow and Blue with Guitar, March 1939

Oil on canvas; 63.5 × 49.5 cm (25 × 19 ½ in.)
Brooks McCormick Estate, 2007.290

Fernand Léger

Fernand Léger's paintings blend the aesthetics of modernity with a deep social purpose. He first adopted Cubism around 1909, after seeing the work of Braque and Picasso in the Parisian gallery of Daniel-Henry Kahnweiler. Although he lived within the creative alchemy of La Ruche (The Hive)—an artist's colony whose inhabitants included Alexander Archipenko, Marc Chagall, Robert Delaunay, and Jacques Lipchitz—he had very little contact with the founders of Cubism, who inhabited a different area of the city. His efforts differed significantly from the subtly shaded shards and neutral monochromes of Analytic Cubism, as he typically fashioned his compositions out of clearly defined volumetric forms and incorporated saturated, primary colors. This preference for bold color and delineated form was consistent throughout his career and is evident in both *The Red Table* (1920; p. 82) and *Divers on a Yellow Background* (1941; p. 85), even though the compositions are separated by more than twenty years.

Léger served in World War I, where he fought alongside people from diverse social backgrounds. The experience profoundly influenced his art. Searching for stability and peace after the war, he found inspiration in the pristine order of classicism. After meeting Le Corbusier in 1920, his work increasingly took on the systematic clarity of Purism—which promoted mathematical order and logic in art and design. During this period, Léger's style shifted from the industrial Cubism of works like *The Railway Crossing (Sketch)* (1919; p. 82) to the industrial classicism of *Composition in Blue* (1921–27; p. 84). His wartime experiences also encouraged him to seek a means of making an art for everyone. As evident in *The Red Table*, one of his tactics in addressing this goal was to produce what he called "everyday poetic images,"

focused on utilitarian items such as domestic objects, architectural elements, and tools. Even the long-established symbol of exoticizism, the reclining nude harem figure, as seen in *Reclining Woman* (1922; p. 83), found a new form through Léger's brush. Becoming both more modern and more alien, the giant, machine-like female figures in such works as *Composition in Blue* fill his dense compositions like smoke stacks looming over a city skyline. Indeed, industrial elements, particularly metallic, tubular structures, pervade Léger's. His geometric, linear style was in part due to his early experiences as an architect's draftsman, as well as to the artist's personal fascination with machines, which we he maintained were as important to his art as people.

Although his figures never lost their smoothly massive forms or quasimechanical appearance, by the mid-1930s Léger began to incorporate organic forms into his work, informed by the natural rather than manmade world. Painted in the United States during World War II, *Divers on a Yellow Background* draws on the artist's memory of swimmers diving off the docks in Marseilles. Even here, the black-and-white mass of expressionless figures at the center of the composition appears as a jumble of nearly interchangeable parts. Whether humanizing the mechanical or mechanizing the human, Léger's art reaffirms a tireless dedication to the industrial nature of the modern environment.

Detail of Fernand Léger, *The Railway Crossing (Sketch)* (1919; p. 82).

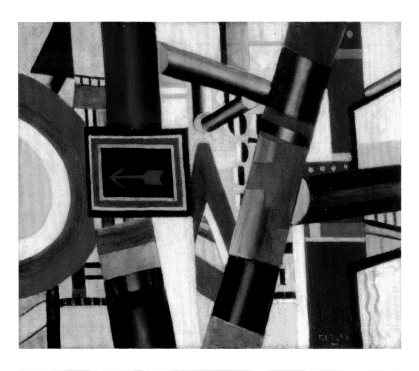

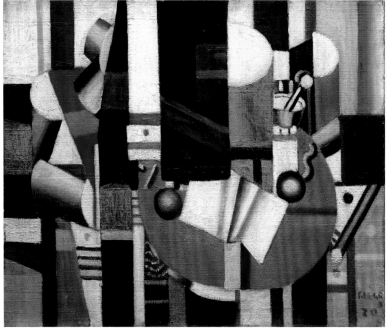

Fernand Léger

French, 1881–1955

The Railway Crossing (Sketch), 1919

Oil on canvas; 54.4 × 65.7 cm (21 ⅜ × 25 ⅞ in.)
Joseph Winterbotham Collection; gift of Mrs. Patrick Hill in
memory of Rue Winterbotham Carpenter, 1953.341

The Red Table, 1920

Oil on canvas; 54.2 × 65 cm (21 ⅜ × 25 ⅝ in.)
Gift of Kate L. Brewster, 1948.557

Fernand Léger

French, 1881–1955

Reclining Woman, 1922

Oil on canvas; 64.5 × 92 cm (25 ½ × 36 ¼ in.)
A Millennium Gift of Sara Lee Corporation, 1999.369

84

Fernand Léger

French, 1881–1955

Composition in Blue, 1921–27

Oil on canvas; 130.6 × 97.5 cm (51 7⁄16 × 38 3⁄8 in.)
Charles H. and Mary F. S. Worcester Collection, 1937.461

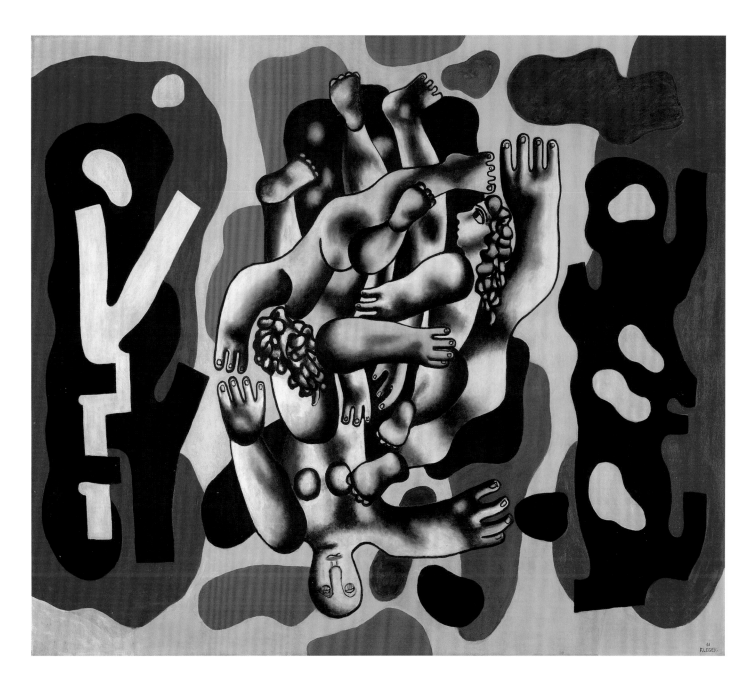

Fernand Léger

French, 1881–1955

Divers on a Yellow Background, 1941

Oil on canvas; 186.7 × 217.8 cm (73 ½ × 85 ¾ in.)
Gift of Mr. and Mrs. Maurice E. Culberg, 1953.176

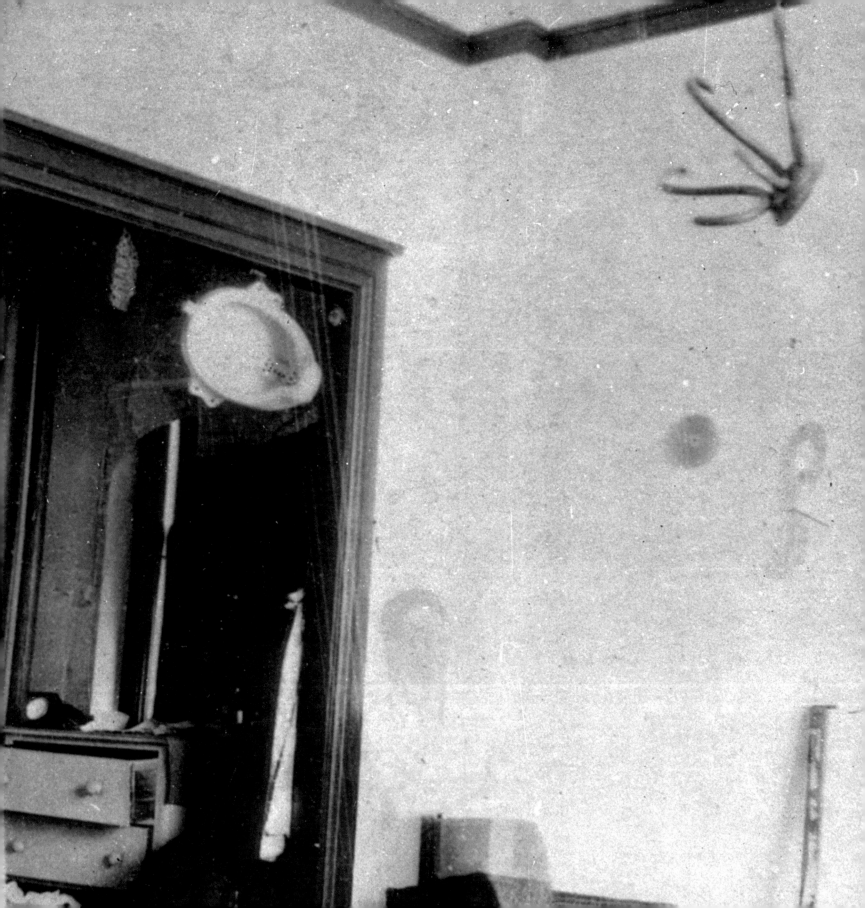

Dada

Born out of the horrors of World War I, Dada originated in the Swiss city of Zurich in 1916. Switzerland's neutral status made it a haven for Europe's fleeing expatriates, and its promise of relative safety fostered an environment in which creative responses to the irrationality of war were still possible. From Zurich the movement spread to other major metropolitan centers, including Berlin, Paris, Cologne, and New York, taking on numerous and at times radically different forms. At its core, however, Dada exhibited a deep distrust of the rationality and positivism valued in the previous century, ideals which many believed had fostered, or at least failed to provide adequate defense against, the mass destruction then sweeping the continent. The very idea of art, with its implied notions of creation, idealism, and beauty, seemed completely absurd in this environment. In its place, Dada advocated "anti-art": objects, performances, and installations that challenged not only the foundations of art but also the values and conventions of the societies that seemingly allowed such atrocities to occur.

Like many Dada works, those by Suzanne Duchamp merge painting, collage, and language together in complex ways. *Broken and Restored Multiplication* (1918–19; p. 91) is filled with visual and verbal metaphors of disorder and breakage: at the center, a schematic Eiffel Tower is turned upside down while just below it a modern cityscape is reflected in its mirror image. The series of phrases that run up and down along the surface of the picture—"the mirror would shatter, the scaffolding would totter, the balloons would fly away, the stars would dim, etc...."—furthers the idea of order upended.

Dada artists typically placed machines and the detritus of mass media and industrialization at the center of their work. This is true in the case of Man Ray's painting *Percolator* (1917; p. 89), in which the metal components of a coffeemaker fill the canvas, thus raising this forgotten mechanical element to a new level of attention. A slightly earlier picture by Man Ray, *Invention* (1916; p. 89), heightens the absurdity of its subject by portraying a nonsensical object, consisting mostly of abstract forms and a handprint. Marcel Duchamp also made art out of mass-produced objects, which he reoriented or minimally altered in ways that caused them to lose their original purpose. If works of art were by definition objects without a function, Duchamp playfully reasoned, then taking away an object's function could make it a work of art. Collectively called Readymades, these items—which include *Hat Rack* (1964, 1916 original now lost; p. 90), a wooden hat rack hung upside down from the ceiling—often existed primarily in his studio for private rather than public consumption. Yet, the dramatic, even sinister, effect of the spider-like shadow cast by *Hat Rack* suggests that Duchamp remained concerned with the contextual effects of the object even in a private space. Simultaneously questioning the value of the handmade object while aestheticizing industrial products, Duchamp's Readymades opened the door to a more purely conceptual basis for art by emphasizing the choice (and therefore, the mind) of the artist above his or her skills.

Duchamp's ghostly presence among his Readymades, including the original version of *Hat Rack* (see p. 90), New York, c. 1917.

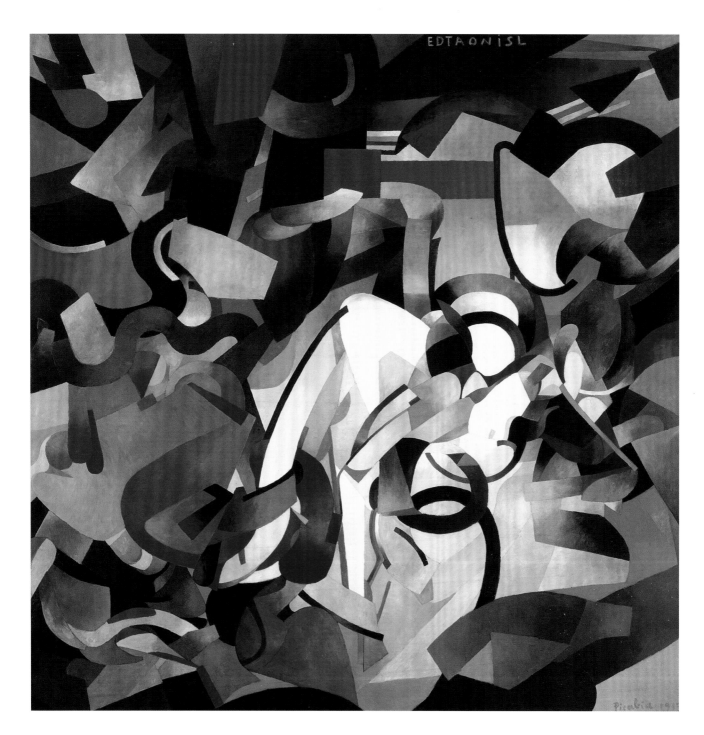

88

Francis Picabia

French, 1879–1953

Edtaonisl (Ecclesiastic), 1913

Oil on canvas; 300.4 × 300.7 cm (9 ft. 10 ¾ × 9 ft. 10 ¼ in.)
Gift of Mr. and Mrs. Armand Bartos, 1953.622

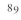

Man Ray

American, 1890–1976

Percolator, 1917

Oil on board; 40.6 × 30.4 cm (16 × 12 in.)
Through prior gift of the Albert Kunstadter Family Foundation,
1989.487

Invention, 1916

Oil on composition board; 62.2 × 47 cm (24 ½ × 18 ½ in.)
Gift of Muriel Kallis Newman in memory of her mother, Ida Kallis,
1980.282

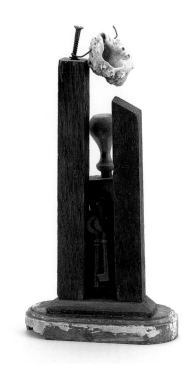

Marcel Duchamp

American, born France, 1887–1968

Hat Rack, 1964 (1916 original now lost)

Wood; 27.5 × 46.1 × 35 cm (10 ⅝ × 18 ⅛ × 13 ¾ in.)
Through prior gifts of Mr. and Mrs. Carter H. Harrison and
Mr. and Mrs. Edward Morris, 1989.54

Marcel Janco

Israeli, born Romania, 1895–1984

Composition with Red Arrow, 1918

Plaster and casein on burlap, mounted on cardboard;
50.2 × 66.7 cm (19 ¾ × 26 ½ in.)
Gift of Mr. and Mrs. Henry Markus, 1963.374

Paul Joostens

Belgian, 1889–1960

Assemblage, 1922

Wood, shell, and keys; 27 × 13 × 6.5 cm (10 ⅝ × 5 ⅛ × 2 ⁹⁄₁₆ in.)
Through prior gift of Arthur Keating, 1990.80

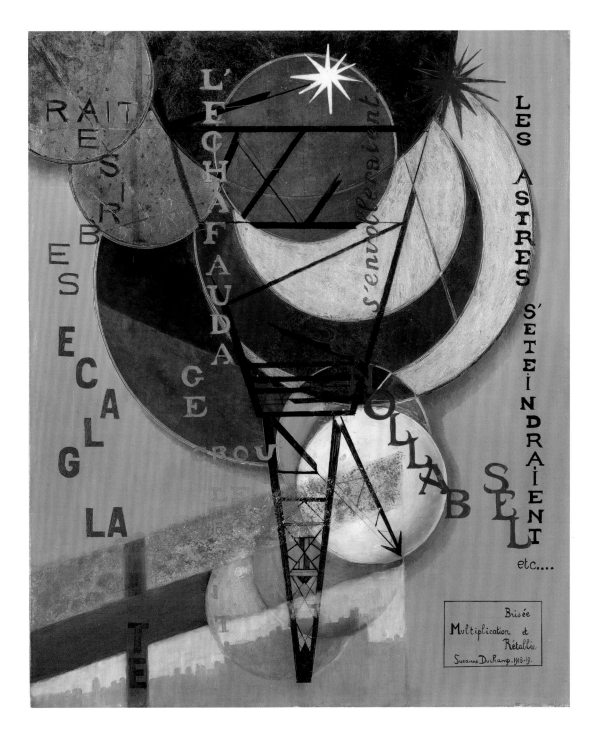

Suzanne Duchamp

French, 1889–1963

Broken and Restored Multiplication, 1918–19

Oil and silver paper on canvas; 61 × 50 cm (24 × 19 ¹¹⁄₁₆ in.)
Gift of Mary P. Hines in memory of her mother, Frances W. Pick; through prior acquisitions of Mr. and Mrs.
Martin A. Ryerson, H. J. Willing, and Charles H. and Mary F. S. Worcester, 1994.552

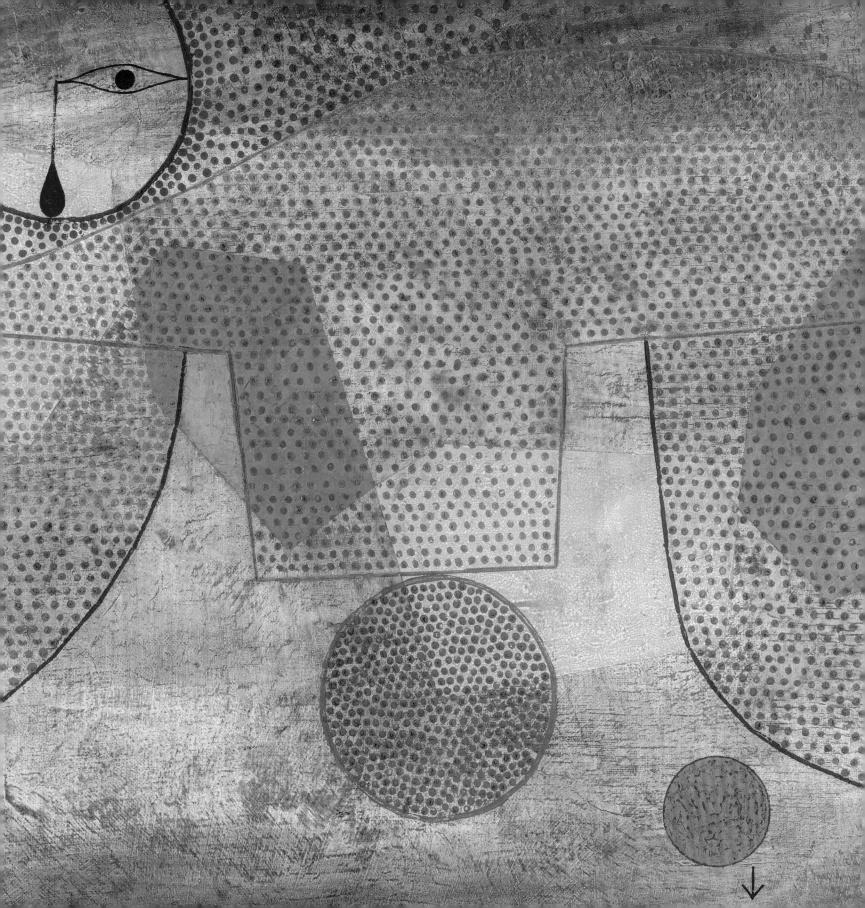

Paul Klee

Painter, printmaker, critic, and theoretician, Paul Klee taught at the famed modernist art school, the Bauhaus (1919–1933), for most of the institution's existence. There he filled many roles, including head of the bookbinding department, supervisor of the glass-painting workshop, and lecturer for the basic design course on the theory of form. With an elastic but meticulous mind, Klee used his lectures to probe the principles of composition. It was also during this time that he developed his ideas about the "polyphony" of painting, based on his interest in simultaneous sensational effects that could be produced through various combinations of formal elements.

Klee was committed to the spiritual nature of art and found inspiration in sources he believed offered direct forms of expression. As a result, he was fascinated by ancient and tribal arts, as well as the creations of children and the mentally ill. Having grown up playing the violin in a musical home, as an adult he also became interested in music's temporal character and its possible translation into pictorial form. Klee, like his friend Vasily Kandinsky, looked to music in his development of abstraction.

Light and color were key to Klee's art, and their importance is especially evident in his paintings from the early 1930s, which incorporate the ideas and techniques of Post-Impressionism. For *Sunset* (1930; p. 95), he utilized both complementary color theory and pointillism to produce a measured, vibrating image through careful orchestration of line, form, and tonal value. Unlike Georges Seurat and Paul Signac, however, who aimed to create a new form of naturalism in painting, Klee sacrificed literal representation in order to focus on making pictorial rhythm from formal structure. The resulting composition—balancing stillness and movement, shallowness and depth—relates to Klee's larger project of looking to music to create an art that "does not reproduce the visible, but makes visible."

Abstraction was not Klee's final goal, however. His oeuvre exhibits a labyrinthine complexity that does not easily break down into discrete phases, and he maneuvered between representation and abstraction for most of his career. It could be argued, in fact, that Klee's most consistent quality as an artist was his apparent delight in the tension between opposites such as line and color, simplicity and detail, meticulousness and spontaneity, and geometry and nature. This tension underscores the ample creativity and sparkling humor that so often marks his work, from *Fleeing Ghost* (1929; p. 94) to the late *Dancing Girl* (1940; p. 95).

Klee left the Bauhaus in 1931 but continued to teach at the Düsseldorf Academy until 1933 when, under Nazi authority, he was dismissed from his position and forced to return to Switzerland, the country of his birth. Although his artistic output decreased dramatically in the years directly following his forced departure, he rebounded by the end of the decade, producing several hundred paintings and over 1,500 drawings between 1937 and 1940 alone. Works such as the lively *Dancing Girl*, "signed" with the monogram of Klee's handkerchief that he laid upon the canvas, exhibit the same spirit of wit, whimsy, and experimentation that had long been a hallmark of his oeuvre.

Detail of Paul Klee, *Sunset* (1930; p. 95).

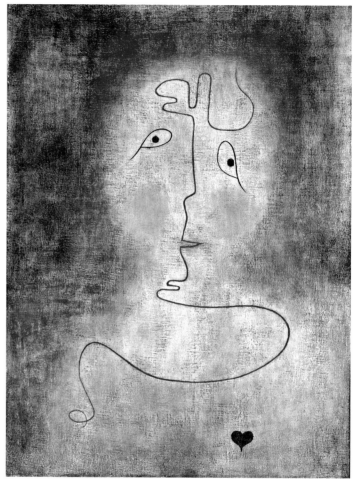

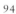

Paul Klee

German, born Switzerland, 1879–1940

Fleeing Ghost, 1929

Oil on canvas; 89.5 × 63.5 cm (35 ¼ × 25 in.)
Bequest of Claire Zeisler, 1991.1500

In the Magic Mirror, 1934

Oil on canvas, on board; 66 × 50 cm (26 × 19 ¾ in.)
Bequest of Claire Zeisler, 1991.321

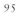

Paul Klee

German, born Switzerland, 1879–1940

Dancing Girl, 1940

Oil on cotton, on board; 52.8 × 52.7 cm (20 ³⁄₁₆ × 20 ¾ in.)
Gift of George B. Young, 1959.172

Sunset, 1930

Oil on canvas; 43.9 × 67.8 cm (17 ¼ × 26 ⅝ in.)
Gift of Mary and Leigh Block, 1981.13

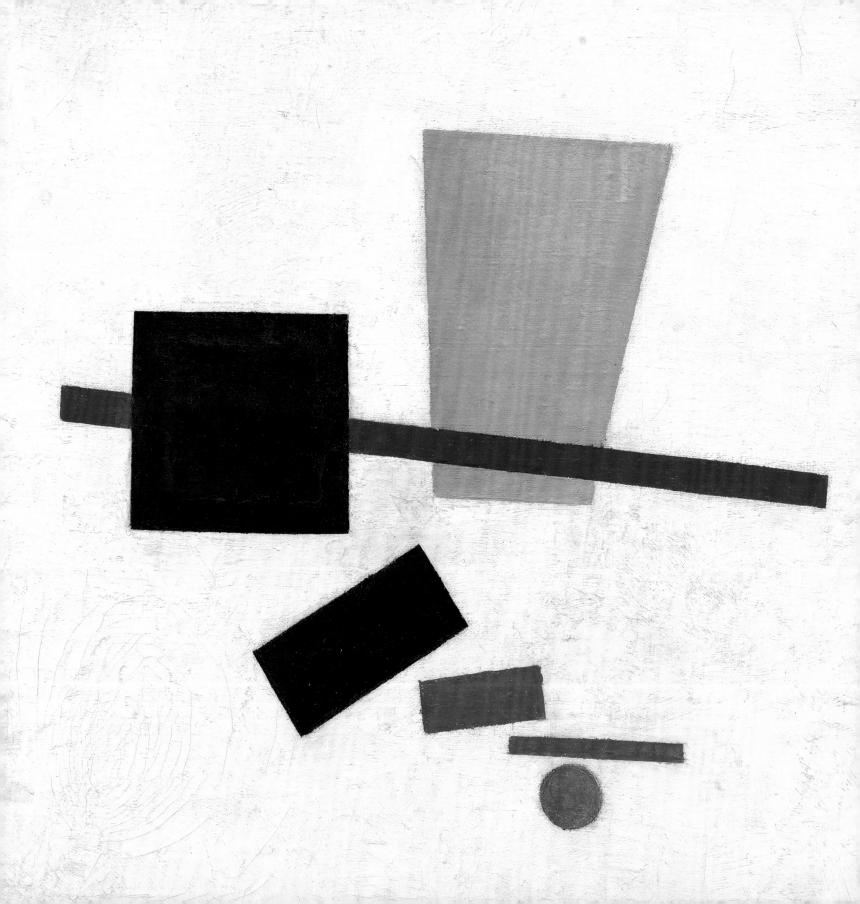

Abstraction

It can be said that the history of twentieth-century art is one of a continual and evolving effort for freedom from the traditions and strictures of the past. At the apex of this struggle was abstraction—a development that radically shattered art's remaining connections to the recognizable physical world. Whether inspired by music as the only intangible art form or the utopian language of pure geometry and color, abstract art is widely recognized today as the greatest artistic achievement of the last century.

Kazimir Malevich pushed art to its nonobjective essence through his own variant of abstraction, Suprematism. In 1915 he brought this vision to its fully realized form in the creation of works like *Painterly Realism of a Football Player—Color Masses in the 4th Dimension* (1915; p. 100), which focuses on the inherent relationships of colored geometric shapes against a white background. Considered a pure, fundamental embodiment of painting, Suprematism offered a radically new formal vocabulary, influenced by space-time physics and ideas about the fourth dimension.

In 1917 Theo van Doesburg founded an art periodical in Leiden, *De Stijl (The Style)*. This name also referred to the group of artists associated with the publication, including van Doesburg, Piet Mondrian, and Georges Vantongerloo. These artists saw abstraction as an almost spiritual vehicle to reconstruct art and society following World War I. Their approach, as exemplified by van Doesburg's *Counter-Composition VIII* (1924; p. 105), was marked by complex relationships between the fundamental elements of geometry, color, and balance.

Although van Doesburg was primarily responsible for the founding of De Stijl, the group's ideas were indebted to Piet Mondrian, whose precisely arranged and chromatically restricted paintings represent a pinnacle of twentieth-century abstraction. Mondrian rooted his compositions in the natural world and built environment, and his early landscapes, such as *Farm near Duivendrecht* (c. 1916; p. 98), reveal a particular fascination with the flat, topography of his native Holland. After 1920, Mondrian sought a universal art based on the most essential aspects of color and line. Working intuitively, he made canvases such as *Lozenge Composition with Yellow, Black, Blue, Red, and Gray* (1921; p. 101) by carefully composing straight horizontal and vertical lines and primary colors—red, yellow, and blue—along with black, white, and gray to produce an internal rhythm within a stable but expansive composition. Basing their work on what they perceived to be the most essential components of nature, he and other De Stijl artists hoped to lead the way toward a society founded on the same idealistic principles of universality as their art.

Abstract art continued to have a great appeal for artists working in Europe: in 1929 Michel Seuphor and Joaquín Torres-Garcia founded Cercle et Carré (Circle and Square; later known as Abstraction-Creation). Together, the artists of Cercle et Carré promoted new developments in abstract art, especially its mystical tendencies. For Torres-Garcia's *Object with Number 1* (1932; p. 104) the artist organized various roughly hewn and painted pieces of wood into a three-dimensional structure that suggests both architectural and human form. Indeed, at the top of the construction, in the middle of the red painted square, the artist added the number 1, thus reflecting his theories about the unity of the individual and the cosmos. While small in scale, the work has a profoundly monumental presence.

Detail of Kazimir Malevich, *Painterly Realism of a Football Player—Color Masses in the 4th Dimension* (1915; p. 100).

Piet Mondrian

Dutch, 1872–1944

Farm near Duivendrecht, c. 1916

Oil on canvas; 86.2 × 108.3 cm (33 ¹⁵⁄₁₆ × 42 ⅝ in.)
Gift of Dolly J. van der Hoop Schoenberg, 2001.479
© 2014 Mondrian/Holtzman c/o HCR International,
Washington, D.C.

Le Corbusier (Charles-Édouard Jeanneret)

French, born Switzerland, 1887–1965

Still Life Filled with Space, 1924

Oil on canvas; 60.2 × 73.8 cm (23 ¹¹⁄₁₆ × 29 in.)
Bequest of Richard S. Zeisler, 2007.279

Frantisek Kupka

Czech, 1871–1957

Reminiscence of a Cathedral, 1920–23

Oil on canvas; 150.3 × 94 cm (59 ⅛ × 37 in.)
Gift of Mr. and Mrs. Joseph Randall Shapiro, 1984.6

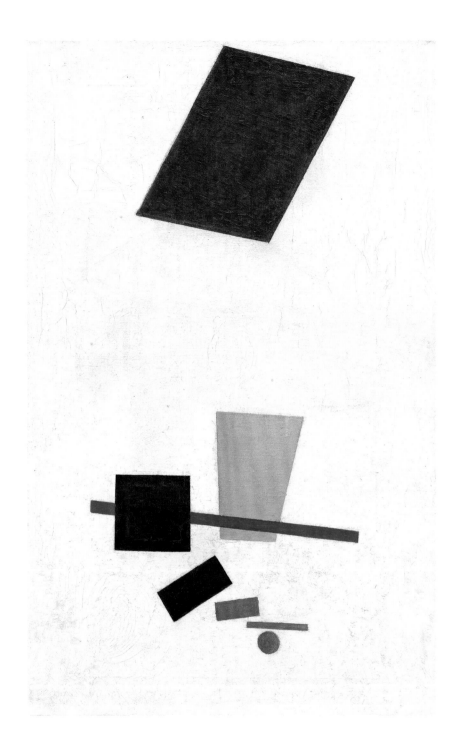

Kazimir Malevich

Russian, born Ukraine, 1878–1935

Painterly Realism of a Football Player—Color Masses in the 4th Dimension,
summer–fall 1915

Oil on canvas, 71 × 44.5 cm (27 × 17 ½ in.) (original); 70.2 × 44.1 cm (27 ⅝ × 17 ⁵⁄₁₆ in.) (present)
Through prior gifts of Charles H. and Mary F. S. Worcester Collection; Mrs. Albert D. Lasker in memory of her
husband, Albert D. Lasker; and Mr. and Mrs. Lewis Larned Coburn Memorial Collection, 2011.1

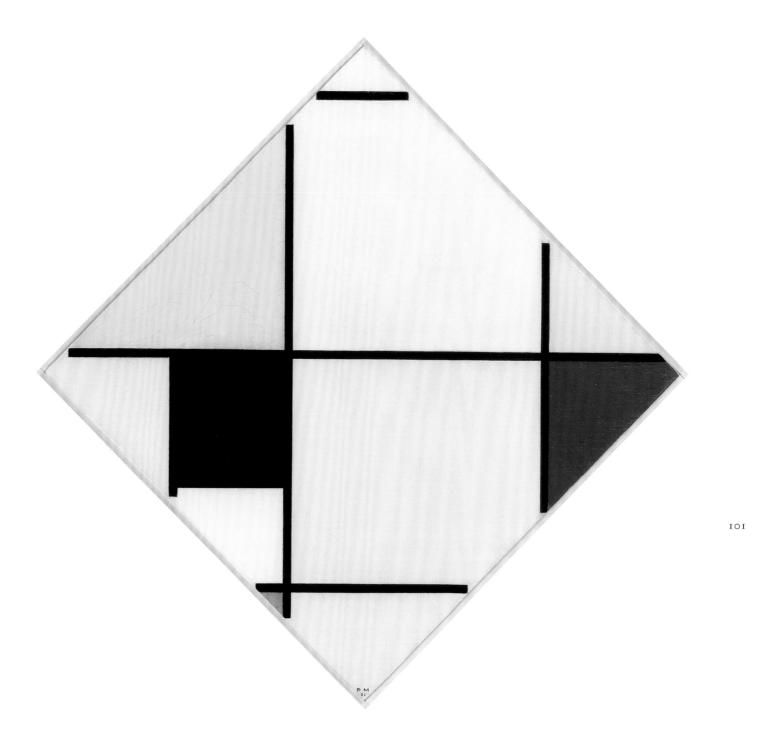

Piet Mondrian

Dutch, 1872–1944

Lozenge Composition with Yellow, Black, Blue, Red, and Gray, 1921

Oil on canvas; 60 × 60 cm (23 ⅝ × 23 ⅝ in.)
Gift of Edgar Kaufmann, Jr., 1957.307
© 2014 Mondrian/Holtzman c/o HCR International, Washington, D.C.

Oskar Schlemmer

German, 1888–1943

Abstract Figure, 1921/23

Bronze and nickel; 105.4 × 62.2 × 20.3 cm (41 ½ × 24 ½ × 8 in.)
Wirt D. Walker Fund, 1968.610

Alexandra Exter

Russian, born Belostok (present-day Bialystok, Poland),
1882–1949

Robot, 1926

Cardboard, fabric, wood, glass, and string; 50.8 cm (20 in.)
Block, Serlin and Saidenberg Fund; through prior gifts of
Mr. and Mrs. Carter H. Harrison, Arthur Keating, Albert
Kunstadter Family Foundation, 1990.133

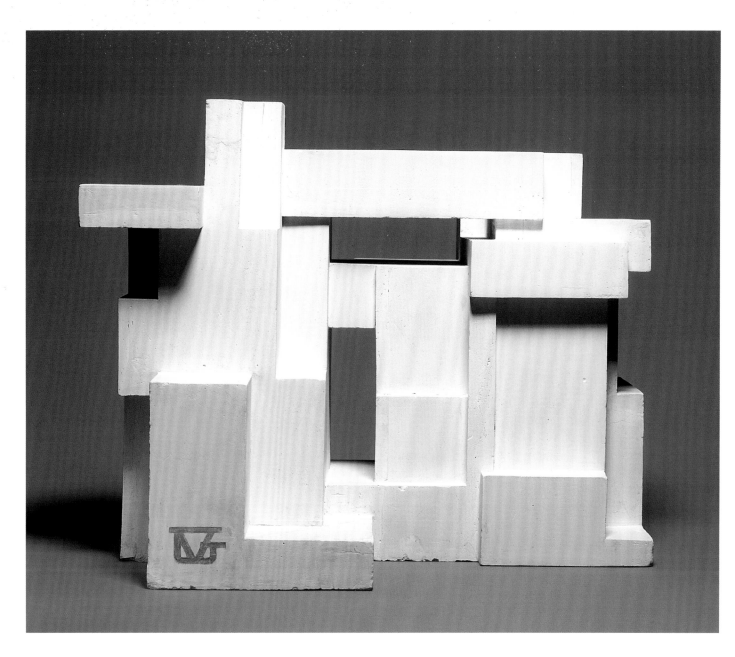

Georges Vantongerloo

Belgian, 1886–1965

Interrelation of Volumes from the Ellipsoid, 1926

Plaster; 40 × 47 × 26 cm (15 ¾ × 18 ½ × 10 ¼ in.)
Through prior gift of Lucille E. and Joseph L. Block; partial gift in memory of Lillian Florsheim, 2004.245

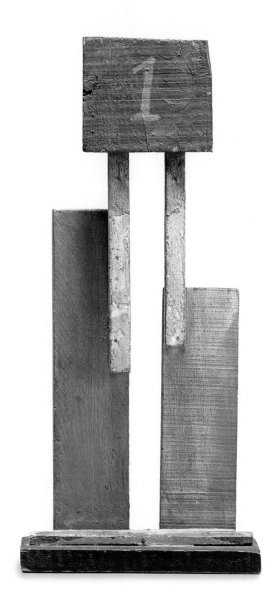

104

Joaquín Torres-Garcia

Uruguayan, worked in Spain and France, 1874–1949

Object with Number 1, 1932

Oil and nails on wood; 47 × 22.5 × 9.2 cm (18 ½ × 8 ⅞ × 3 ⅝ in.)
Through prior gift of Charles H. and Mary F. S. Worcester Collection, 2013.1095

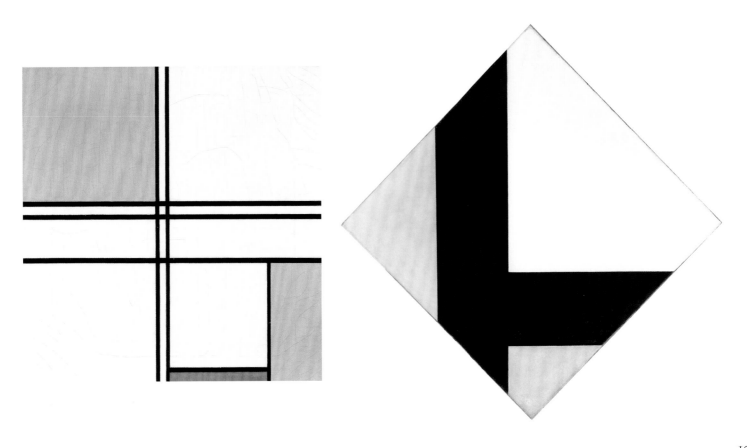

Piet Mondrian

Dutch, 1872–1944

Composition (No. 1) Gray-Red, 1935

Oil on canvas; 56.8 × 54.7 cm (22 ⅜ × 21 ⁹⁄₁₆ in.)
Gift of Mrs. Gilbert W. Chapman, 1949.518
© 2014 Mondrian/Holtzman c/o HCR International, Washington,
D.C

Theo van Doesburg

Dutch, 1883–1931

Counter-Composition VIII, 1924

Oil on canvas; 143.1 × 142.6 cm (56 ⁵⁄₁₆ × 56 ¹⁄₁₆ in.)
Gift of Peggy Guggenheim, 1949.216

Constantin Brâncusi

One of the most innovative artists of the twentieth century, Constantin Brâncusi pioneered abstraction in the realm of sculpture. Inspired by the direct carving of wooden art works in both non-Western cultures and his native Romania, he rejected the prevailing method of modeling in clay favored by his former mentor and employer, Auguste Rodin. Whether by making his objects by direct carving or casting, Brâncusi spent his career searching for the essence of a few key subjects through repeated investigation over many years. *Sleeping Muse* (1910; p. 109) is an example of Brâncusi's continual attempts at simplifying his subject. With this work, he removed the neck and shoulders from the form of a sleeping woman's head so that the truest essence of the subject was revealed. He also suppressed the potential disquiet brought on by the depiction of a separated head by giving it an elegantly abstracted, somewhat ovoid shape. In his pursuit of this particular theme, he would eventually remove the face and hair, pushing the form towards the perfectly smooth simplicity of an egg.

Brâncusi's concern with essence also extended to the qualities of his materials, and he strove to match medium to form. As a result, he might repeat certain shapes in the hard, smooth, and pristine media of bronze and marble but would never carve them into the more porous, nonreflective substances of wood and limestone. Likewise, he never cast the angular, geometric designs of his wooden objects in metal. His oeuvre balances on the contrast between the highly polished, almost industrial appeal of his bronze and marble objects and the cultivated "primitive" aesthetic of those in wood and limestone. Indeed, he eventually moved to the combination of forms, making sculptures that exist as stacked accumulations of individual elements in various media. Consistent with his meticulous method of creation, the artist arranged these elements precisely and in different combinations to create an ideally balanced totality from a variety of angles. This modular construction is particularly important to his *Birds in Space* series, including the early *Golden Bird* (1919/20, base c. 1922; p. 111). Here, the juxtaposition of the gleamingly smooth, highly worked surface of the "bird" with the weighty angularity of the stone and wood elements heightens the sculpture's overall sensation of movement, as the aerodynamic body seems to push off from the earth-bound elements below it. Conjuring more than the form of a bird in flight, Brâncusi conveyed the sculpture's sense of motion by anticipating the enlivening play of light upon the metallic surface of *Golden Bird* as it points relentlessly upward.

Brâncusi soon moved from arranging the individual elements of his stacked compositions to arranging the finished sculptures in relation to each other. His studio had become as much a display space as a work space, and he turned to curating and photographing its contents. Visitors to the studio described it in mystical, awe-inspiring terms. According to fellow artist Man Ray, entering the space was like "penetrating into another world."

Brâncusi at work in his studio with an alternate version of *Golden Bird* (see p. 111), early 1922.

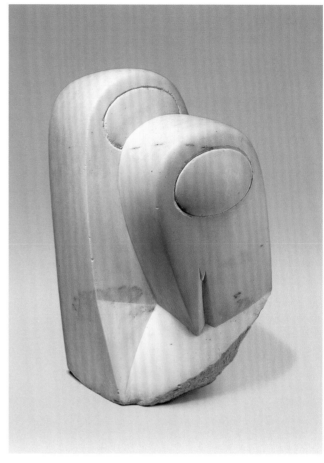

Constantin Brâncusi

French, born Romania, 1876–1957

Wisdom, c. 1908

Limestone; 56.5 × 18.4 × 36.3 cm (22 ¼ × 7 ¼ × 14 ¼ in.)
Ada Turnbull Hertle Fund, 1955.646

Two Penguins, 1911–14

Marble; 54.7 × 32.2 × 33.2 cm (21 9/16 × 12 ¾ × 13 ⅛ in.)
Ada Turnbull Hertle Fund, 1961.1115

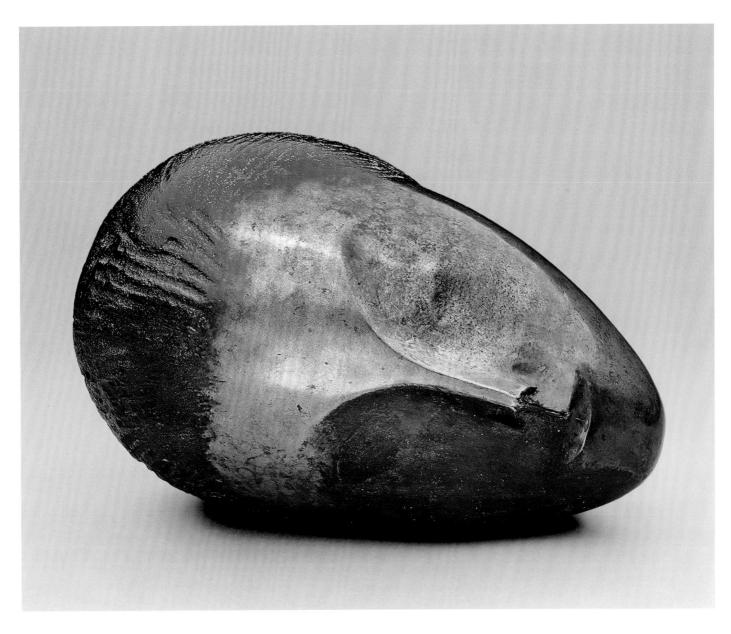

Constantin Brâncusi

French, born Romania, 1876–1957

Sleeping Muse, 1910

Bronze; 17.3 × 20 × 27.1 cm (6 ¹³⁄₁₆ × 7 ⅞ × 10 ⅞ in.)
Arthur Jerome Eddy Memorial Collection, 1931.523

Constantin Brâncusi

French, born Romania, 1876–1957

White Negress II, 1928

White marble, black marble, stone, and wood
sculpture: 49.5 × 14.5 × 19. cm (19 ½ × 5 3/4 × 7 ½ in.); black
marble base: 36.9 × 36.9 × 25.4 cm (14 ½ × 14 ½ × 10 in.); stone
base: 53.3 × 50.8 × 42 cm (21 × 20 × 16 ½ in.); wood base: 45.1 ×
43.2 × 35 cm (17 ¾ × 17 × 13 ¾ in.)
Grant J. Pick Collection, 1966.4

Leda, c. 1920

Marble on concrete base; sculpture: 58.5 × 76.2 × 21.6 cm
(23 × 30 × 8 ½ in.); base: h. 66 cm (26 in.) outside diam. 124.5 cm
(49 in.); total h. 124.5 cm (49 in.)
Bequest of Katherine S. Dreier, 1953.195

Constantin Brâncusi

French, born Romania, 1876–1957

Golden Bird, 1919/20 (base c. 1922)

Bronze, stone, and wood; 218.4 × 29.9 × 29.7 cm (86 × 11 ¾ × 11 ¹¹⁄₁₆ in.)
Partial gift of the Arts Club of Chicago; restricted gift of various donors; through prior bequest of Arthur Rubloff; through prior restricted gift of William E. Hartmann; through prior gifts of Mr. and Mrs. Carter H. Harrison, Mr. and Mrs. Arnold H. Maremont through the Kate Maremont Foundation, Woodruff J. Parker, Mrs. Clive Runnells, Mr. and Mrs. Martin A. Ryerson, and various donors, 1990.88

Max Ernst

Max Ernst's dedication to investigating dreams, memories, and the unconscious culminated in his influential roles as a leader of Dada in Cologne, Germany, and as a founding member of Surrealism in Paris. Perhaps his most important contributions to both movements were his innovative techniques that enabled artists to access, utilize, or stimulate their unconscious minds. During his association with Dada, for example, Ernst merged nineteenth-century instructional manuals and the methods of collage to create seamless yet absurd quasi-narrative scenes.

In the mid- to late 1920s, Ernst combined Surrealism's interests in the unconscious actions of pure psychic automatism and the suggestive character of found objects when he developed the techniques of frottage and grattage. The invention of frottage was inspired by a debate among the recently formed Surrealists about the possibility of applying automatism to painting. Hoping to harness the unconscious for the visual arts, Ernst made rubbings of the surfaces placed behind his freshly painted canvases. He then refined the resulting patterns by drawing out and enhancing certain elements in order to create more legible images, as evidenced in *The Blue Forest* (1925; p. 114). Frottage also appears in the petrified trees of *Forest and Sun* (1927; p. 116), but he used grattage—the process of scraping paint off the canvas—to create the sun at the composition's center.

Like many of his fellow Surrealists, Ernst looked to dreams as a gateway to the unconscious and a rich source of imagery. The most potent dreams for the artist were those that related to memories of childhood, and over the years he created a personal mythology based on these early recollections. Much of his production aimed to disrupt or undermine the conventions and morals of the culture of his childhood. While his early works may have been somewhat satirical, Ernst's experiences in World War I solidified the severity of his future rejection of social norms. As a result, works such as *Spanish Physician* (1940; p. 117) often possess a vaguely menacing character and address themes of sexuality and violence.

After the outbreak of World War II, Ernst fled to New York with the help of Peggy Guggenheim. In the United States, he frequently utilized another chance-based technique, decalcomania, in which a paint-covered surface is pressed against and then removed from a canvas, leaving unexpected and surprising forms. Similar to how he used frottage, he employed decalcomania to make landscapes and rock formations. In 1941 Ernst first traveled to the American Southwest. The experience was revelatory: he proclaimed that his visionary Surrealist paintings seemed to him like premonitions after he first saw the vast hallucinatory landscapes of the desert. In 1943 he visited Sedona, Arizona, with his wife, artist Dorothea Tanning, and was inspired to create paintings like *Summer Night in Arizona* (1944; p. 117), which draw upon the dreamlike quality of the rugged, brilliantly colored landscapes of the West and the automatic techniques Ernst had perfected over the years. The couple would live in Sedona from 1946 until 1953, when they returned to France.

Detail of Max Ernst, *Spanish Physician* (1940; p. 117).

Max Ernst

French, born Germany, 1891–1976

The Blue Forest, 1925

Oil on canvas; 116.4 × 73.3 cm (45 13/16 × 28 7/8 in.)
Joseph Winterbotham Collection, 1988.221

Max Ernst

French, born Germany, 1891–1976

Human Figure with Two Birds, 1925 and 1929

Oil on emery paper, mounted on scrap-wood panel covered with industrial-grade black paper;
116.4 × 39.4 cm (45 ⅞ × 15 ½ in.)
Through prior gift of the Albert Kunstadter Family Foundation, 1989.386

Max Ernst

French, born Germany, 1891–1976

Forest and Sun, 1927

Oil on canvas; 65.4 × 81.7 cm (25 ¾ × 32 ⅛ in.)
Bequest of Richard S. Zeisler, 2007.276

Max Ernst

French, born Germany, 1891–1976

Spanish Physician, 1940

Oil on canvas; 38.1 × 55.2 cm (15 × 21 ¾ in.)
Gift of Mr. and Mrs. Joseph Randall Shapiro, 1996.392

Summer Night in Arizona, 1944

Oil on canvas; 28.4 × 43.6 cm (11 ³⁄₁₆ × 17 ³⁄₁₆ in.)
Gift of Mrs. Julien Levy, 1983.1507

Surrealism

Surrealism was founded in 1924, when the critic and poet André Breton published his artistic call to arms, the *Surrealist Manifesto*. Drawing on the theories of Sigmund Freud, Breton championed the unconscious as the wellspring of the imagination and urged poets and painters alike to access this normally untapped realm. Defining it as a method of creation rather than as a discrete style, Breton described Surrealism as "psychic automatism in its pure state . . . the dictation of thought, in the absence of any control exercised by reason, and outside all moral or aesthetic consideration."

The Surrealists utilized various games and techniques to liberate themselves from the confines of convention. Automatic drawing, in which the artist allowed his or her hand to move over the paper without deliberate thought or control, was among the most important of these methods for Surrealist artists. The resulting image was believed to be a product of the mind in its freest state as well as one of chance. In addition to prizing the unconscious, the Surrealists actively sought out other untraditional sources, including non-Western art. Alberto Giacometti's *Spoon Woman* (1926–27; p. 121), for instance, clearly demonstrates the artist's indebtedness to African objects. The figure's large, concave torso was probably inspired by a specific type of spoon carved by the Dan people of western Africa, and the metamorphic quality of the sculpture—simultaneously evoking the shape of a woman and of a spoon—is typical of Surrealist art. In this case, the work also literalizes the purpose of a fetishized object, another common trope in Surrealism, as the giant spoon stands in for the body of a woman. By the end of the 1930s such artists as Claude Cahun,

Salvador Dali, and Man Ray tackled the traditions of sculpture by making new kinds of objects. Curious, whimsical, and sometimes disturbing works like *Object* (1936; p. 124) and *What We All Lack* (1935; p. 123) are composed of everyday and found elements arranged in provocative combinations that confront reason and summon poetic associations.

Surrealism offered a renewal of Symbolism as well, but with a more intensely personal character. Drawing from the metaphysical paintings of Giorgio de Chirico and the Dada collages of Max Ernst, artists including Paul Delvaux and Salvador Dalí employed highly detailed, representational styles to depict irrational scenes through surprising juxtapositions of figures or objects. Their subjects were often based on dreams or distant memories; in some cases, such as Delvaux's *The Awakening of the Forest* (1939; p. 120), these personal references became conflated with the characters and stories of mythology and literature. Dalí was particularly apt at communicating his dreams of an often horrific world, as seen in his *Inventions of the Monsters* (1937; p. 130), which he made both more strange and more believable through the use of a highly detailed, realistic style. Yves Tanguy also created dreamy, seemingly photorealistic landscapes but populated the desert-like environments of paintings like *The Rapidity of Sleep* (1945; p. 122) with abstract, amorphous shapes. Tanguy's work thereby straddles the two primary branches of Surrealism: the stylistically realistic, which attempted to give tangibility to impossible places and events, and the biomorphic, a more abstract expression of the unconscious, exemplified in the paintings of Joan Miró and the sculpture of Jean (Hans) Arp.

Man Ray with an early state of his *Chess Set* (see p. 123), c. 1921.

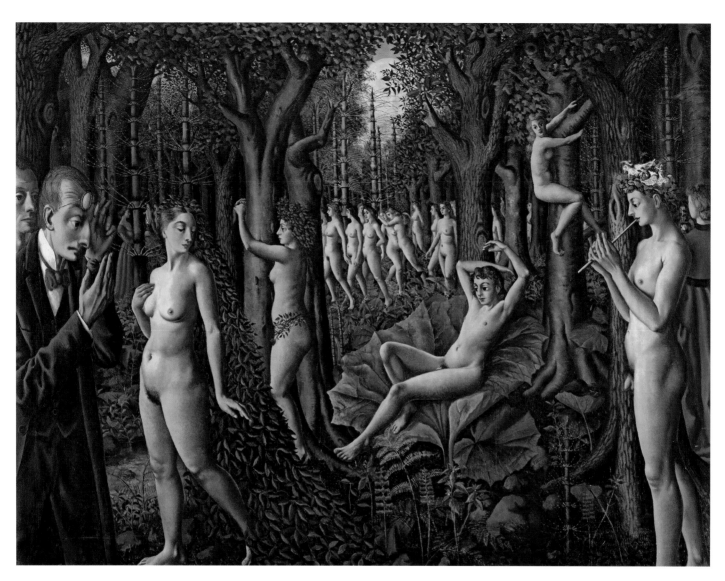

Paul Delvaux

Belgian, 1897–1994

The Awakening of the Forest, 1939

Oil on canvas; 170.2 × 225.5 cm (67 ¹⁄₁₆ × 88 ¾ in.)
Joseph Winterbotham Collection, 1991.290

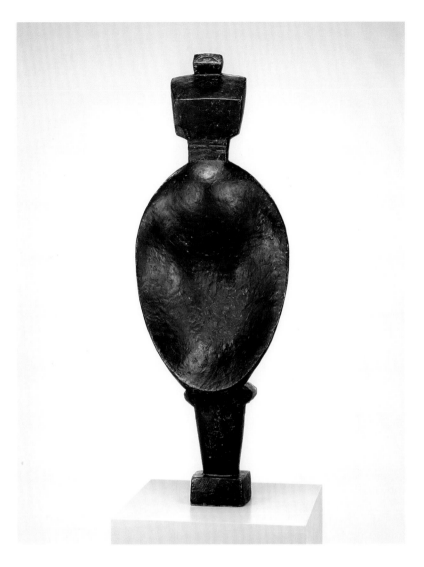

Alberto Giacometti

Swiss, 1901–1966

Spoon Woman, 1926–27

Bronze; 144.9 × 21 × 53 cm (57 × 8 5/16 × 20 7/8 in.)
Gift of Florene May Schoenborn, 1971.880

Head, 1934

Bronze, edition number one of six; 18 × 20 × 20.2 cm
(7 1/16 × 7 7/8 × 8 in.)
Gift of Skidmore, Owings and Merrill, 1961.1113

Henry Moore

English, 1898–1986

Figure, 1937

Marble; 53.4 × 35.6 × 22.9 cm (21 × 14 × 9 in.)
Gift of Edgar Kaufmann, Jr., 1950.1521

Yves Tanguy

American, born France, 1900–1955

The Rapidity of Sleep, 1945

Oil on canvas; 127.7 × 101.9 cm (50 ¼ × 40 ⅛ in.)
Joseph Winterbotham Collection, 1946.46

Man Ray

American, 1890–1976

Chess Set, 1927

Brass, silver, and gold; h. 10 cm (4 in.)
Restricted gift of Mary P. Hines in memory of Harold H. Hines, Jr.; Samuel A. Marx Endowment, 1991.98

What We All Lack, 1963
(1935 original now lost)

Clay pipe with glass ball; 37.5 × 20.3 × 8.9 cm
(14 ¾ × 8 × 3 ½ in.)
Gift of Mary P. Hines in memory of her mother,
Frances W. Pick, 1995.238

Cadeau (Gift), 1963
(1921 original now lost)

Flatiron and 14 iron tacks; 15.3 × 9 × 11.4 cm
(6 ⅛ × 3 ⅝ × 4 ½)
Through prior gift of Mrs. Gilbert W. Chapman, 2009.129

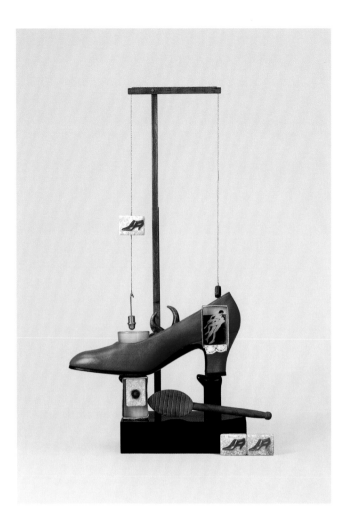

Salvador Dalí

Spanish, 1904–1989

Scatological Object Functioning Symbolically, 1930/73

Assemblage; 48.7 × 28 × 10.2 cm (19 ⅛ × 11 × 4 in.)
Through prior gift of Mrs. Gilbert W. Chapman, 2011.262

Claude Cahun

French, 1894–1954

Object, 1936

Wood, paint, and hair; 13.7 × 10.7 × 16 cm
(5 ⅜ × 4 × 6 ⅜ in.)
Through prior gift of Mrs. Gilbert W. Chapman, 2007.30

René Magritte

Belgian, 1898–1967

The Eye, 1932/35

Oil on canvas; 27 × 24.8 × 14.4 cm (10 ½ × 10 × 2 ½ in.)
Through prior gift of Arthur Keating, 1989.53

René Magritte

Belgian, 1898–1967

Time Transfixed, 1938

Oil on canvas; 147 × 98.7 cm (57 ⅞ × 38 ⅞ in.)
Joseph Winterbotham Collection, 1970.426

Victor Brauner

Romanian, 1903–1966

Turning Point of Thirst, 1934

Oil on canvas; 50.5 × 59 cm (19 ⅞ × 23 ¼ in.)
Promised gift of Mr. and Mrs. Joseph Pulitzer, Jr.; restricted gift of Richard
Gray; Alyce and Edwin De Costa and the Walter E. Heller Foundation,
1992.652

Wolfgang Paalen

Austrian, 1905–1959

L'autophage (Fulgurites), 1938

Oil/fumage on cardboard laid down on wood; 12 × 16.5 cm (4 ¾ × 6 ½ in.)
Through prior gift of Mrs. Gilbert W. Chapman, 2011.125

René Magritte

Belgian, 1898–1967

On the Threshold of Liberty, February–March 1937

Oil on canvas; 238.8 × 185.4 cm (94 × 73 in.)
Gift of Mary and Leigh Block, 1988.141.10

Salvador Dalí

Spanish, 1904–1989

Venus de Milo with Drawers, 1936

Painted plaster with metal pulls and mink pompons; 98 × 32.5 × 34 cm
(38 ⅝ × 12 ¾ × 13 ⅜ in.)
Through prior gift of Mrs. Gilbert W. Chapman, 2005.424

Visions of Eternity, 1936/37

Oil on canvas; 209.5 × 119 cm (82 ½ × 46 ⅞ in.)
Gift of Mr. and Mrs. Joseph Randall Shapiro, 1987.318

Yves Tanguy

American, born France, 1900–1955

Untitled, 1928

Oil on wood; each panel: 200 × 59.7 cm (78 ¾ × 23 ½ in.)
Joseph Winterbotham Collection, 1988.434

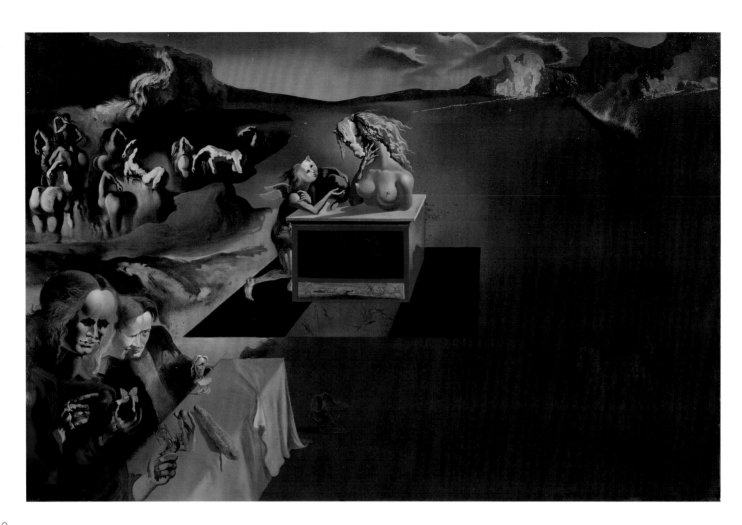

Salvador Dalí

Spanish, 1904–1989

Inventions of the Monsters, 1937

Oil on canvas; 51.4 × 78.3 cm (20 ½ × 30 ⅞ in.)
Joseph Winterbotham Collection, 1943.798

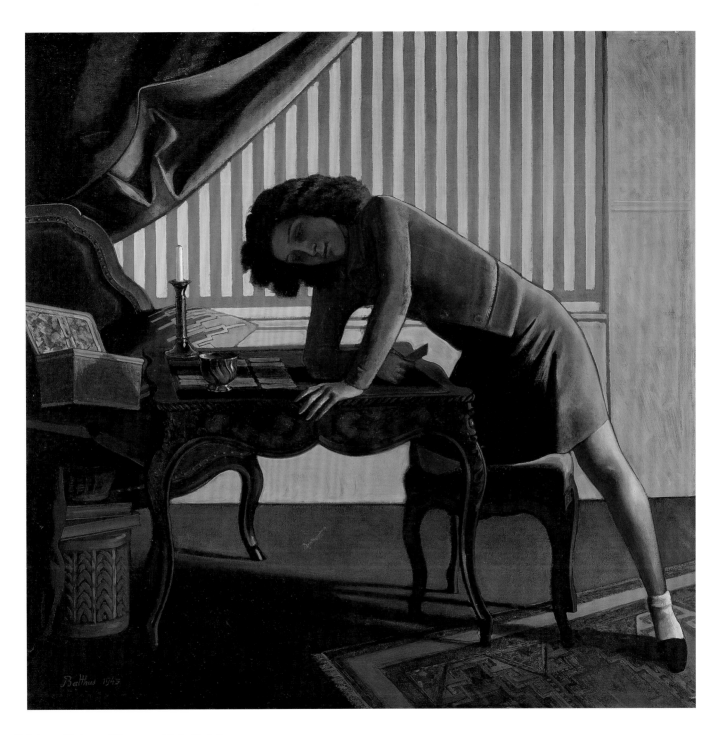

Balthus (Baltusz Klossowski de Rola)

French, 1908–2001

Solitaire, 1943

Oil on canvas; 161.6 × 164.5 cm (63 ⅝ × 64 ¾ in.)
Joseph Winterbotham Collection, 1964.177

Joseph Cornell

Although Joseph Cornell never left the confines of the New York City area, he was steeped in the history and culture of Europe, especially that of the Grand Tour: in his art he referenced European 19th-century opera and ballet, Romantic literature, and Italian architecture. Yet his work also evolved within the context of the European invention of Surrealism and connects to many of the movement's principal goals and themes, especially the promotion of the object, the interest in mysterious juxtapositions and the poetry of the commonplace, and the attention to dreams and other, more personal worlds.

A self-taught artist, Cornell encountered the startling art of Surrealists Salvador Dalí, Max Ernst, and Man Ray in the late 1920s and early 1930s, and he began to make collages of old engravings in the manner of Max Ernst (*La Femme 100 têtes*, 1929). He later shared these works with Julien Levy, an art dealer whose gallery was a critical venue in New York for Surrealism. Levy gave Cornell his first solo exhibition, featured his work in his important early anthology of Surrealist art and literature (*Surrealism*, 1936), and introduced him to many of the leading Surrealist writers and artists of the time. Cornell's work was also included in the first Surrealist group show in the United States, at the Wadsworth Athenaeum in 1935, and, a year later, in the Museum of Modern Art's seminal exhibition *Fantastic Art, Dada, and Surrealism*.

Cornell is best known for his box constructions—intimately scaled, handmade shadow boxes containing evocative combinations of images or objects, works he imagined as "poetic theaters or settings wherein are metamorphosed the elements of a childhood pastime." The boxes range widely in mood, from playful (see p. 135) and luminous to dark and gothic (see p. 134). Even as they offer strange juxtapositions and in some instances approach pure abstraction, Cornell's boxes remain distillations of memories and experiences. His artistic practice was an unusual mix of collecting and fabricating—he amassed a variety of objects, storing them for future use, and compiled research on subjects that would reappear as themes in his boxes. Cornell worked on more than one box at a time, over fairly long periods. He often would leave a box unfinished for months or even years, only to return to it at a later date to finish it or to decide it was complete.

Cornell was also passionately involved in cinema and made films of his own. His first, *Rose Hobart* (1936), was composed of existing film stock that he found and spliced together. Cornell shared his films with the Surrealists, including Dalí, who was present for the first screening of *Rose Hobart* at the Julien Levy Gallery. Whether reorganizing film or assembling three-dimensional found objects into small, boxlike worlds, the practice of recycling forms to create new expressions is central to Cornell's work.

Detail of Joseph Cornell, *Untitled (Forgotten Game)* (c. 1949; p. 135).

Joseph Cornell

American, 1903–1972

Untitled (Black Hunter), c. 1939

Box construction with painted glass; 30.5 × 20.3 × 7 cm (12 × 8 × 2 ⅞ in.)
Lindy and Edwin Bergman Joseph Cornell Collection, 1982.1844

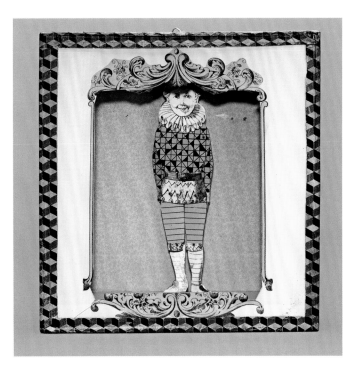

Joseph Cornell

American, 1903–1972

Untitled (Forgotten Game), c. 1949

Box construction; 51.1 × 40.5 × 9.9 cm
(21 ⅛ × 15 ½ × 3 ⅞ in.)
Lindy and Edwin Bergman Joseph Cornell Collection,
1982.1852

Untitled (Harlequin), 1935/38

Box construction; 33.3 × 32 × 6.9 cm
(13 ⅛ × 12 ⅝ × 2 ¾ in.)
Lindy and Edwin Bergman Joseph Cornell Collection,
1982.1843

Untitled (Blue Sand Box), early 1950s

Box construction; 23.8 × 38.2 × 4.8 cm
(9 ⅜ × 15 ⅛ × 1 ⅞ in.)
Lindy and Edwin Bergman Joseph Cornell Collection,
1982.1860

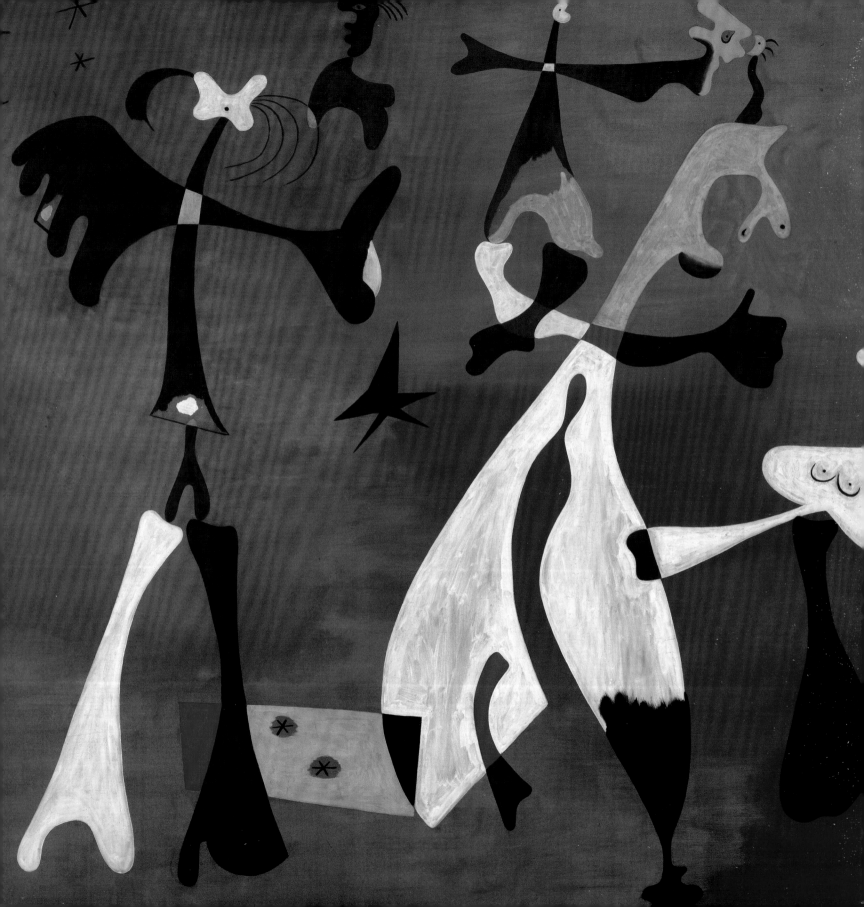

Biomorphic Abstraction

Soon after Joan Miró moved to Paris in 1920, he met a group of painters and writers united in merging the unconscious and rational worlds in order to produce the new language of Surrealism. To access this higher realm, they embraced automatism, a spontaneous working method much like free association. Between 1925 and 1927, Miró's experiments in automatism unleashed a revolutionary series of "dream paintings," including *The Policeman* (1925; p. 141), that are composed of freely moving, calligraphic forms that emerged through the artist's spontaneous mode of working. "Rather than setting out to paint something," he said, "I begin painting and . . . the picture begins to assert itself, or suggest itself under my brush. . . . Even a few casual wipes in cleaning my brush may suggest the beginning of a picture."

In 1936, having long since declared his intention to "assassinate painting" and upend its traditional hierarchies of materials and subject matter, Miró began a series of works on Masonite, which he favored for its raw texture and ability to be worked in ways dramatically different from conventional canvas. Compositions such as *Painting* (1936; p. 142) demonstrate Miró's use of new artistic materials, including gravel and sand mixed into oil paint. Fascinated with the rough effect, the artist told his dealer not to be concerned if any of the materials came loose when he sent work to an exhibition overseas, since it would "make the surface . . . look like an old crumbling wall, which will give great force to the formal expression."

Unlike Surrealist leader André Breton, who attempted to defend the movement from mainstream appropriation, Miró embraced the expanded possibilities for Surrealism. In addition to designing theater sets, back-drops, and costumes, he was also involved in the decorative arts. *Personages with Star* (1933; p. 143), for example, is one of four cartoons for tapestries commissioned in 1933 by the French art collector and gallery director Marie Cuttoli.

Alongside Miró, Jean (Hans) Arp was a leader in the development of the organic language of biomorphism, which infused Surrealism with forms of growth, fecundity, and the natural world. He experimented with spontaneous and seemingly irrational methods of artistic creation, embracing the notion of chance. In the early 1930s, Arp began to translate his abstract style into three-dimensional sculptures, emphasizing metamorphosis in art. Perhaps best known for his freestanding sculptures in plaster, stone, and bronze, Arp also challenged traditional artistic media, seeking to make abstract collages and machine-sawn wood reliefs that existed between the disciplines of painting and sculpture. Made of curvilinear, organic shapes, Arp's reliefs explore a new language that he shared with Miró, André Masson, and other artists associated with Surrealism. Though Arp's works are abstract, titles like *Manicure-Relief* (1930; p. 140) or *Growth* (1938/60; p. 140) often serve as witty suggestions of a work's counterpart in the physical world. Such abstracted, biomorphic expressions of the unconscious would prove to be fruitful precedents for artists in New York after the Second World War and the development of Abstract Expressionism.

137

Detail of Joan Miró, *Personages with Star* (1933; p. 143).

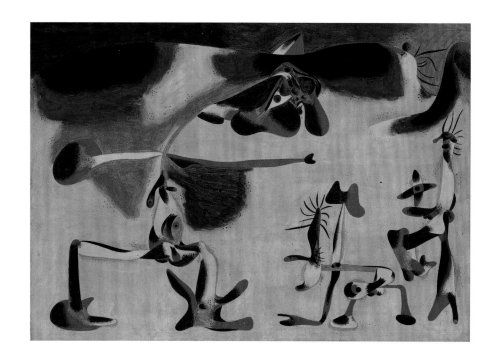

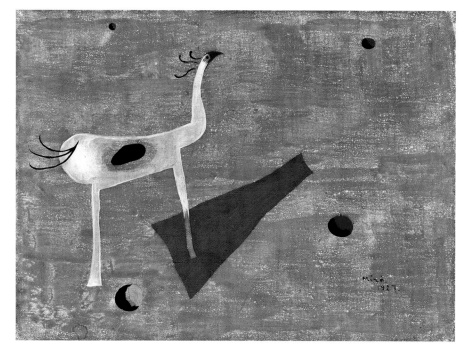

Joan Miró

Spanish, 1893–1983

Two Personages in Love with a Woman,
April 29–May 9, 1936

Oil on copper; 26 × 34.9 cm (10 ¼ × 13 ¾ in.)
Gift of Mary and Leigh Block, 1994.35

Circus Horse, 1927

Oil and tempera on canvas; 24.2 × 33 cm (9 ½ × 13 in.)
Gift of Mary and Leigh Block, 1988.141.12

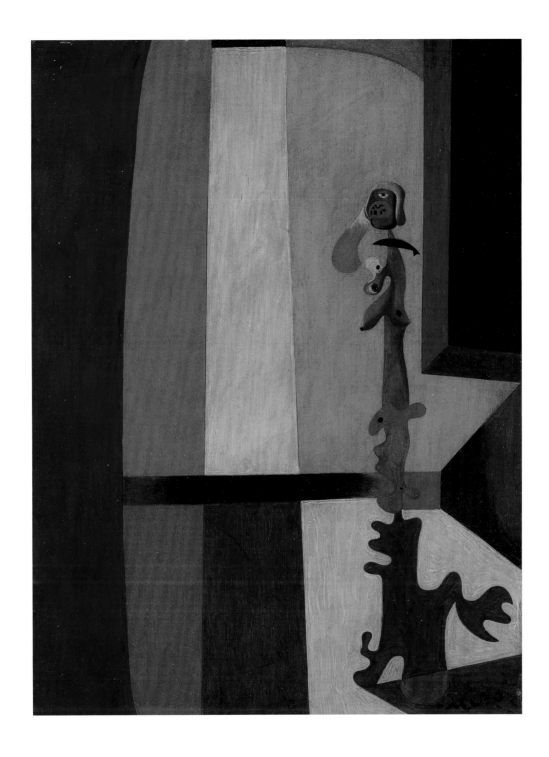

Joan Miró

Spanish, 1893–1983

Figure, 1932

Oil on panel; 27.3 × 20 cm (10 ¾ × 7 ⅞ in.)
Gift of Mary and Leigh Block, 1988.141.13

140

Jean (Hans) Arp

French, born Germany (Alsace), 1886–1966

Manicure-Relief, 1930

Painted wood; 32 × 46.4 cm (12 ⅝ × 18 ¼ in.)
Gift of Frank B. Hubachek, 1951.200

Configuration, 1952

Oil on wood; 81.3 × 59.7 cm (29 ½ × 23 ½ in.)
Bequest of Maxine Kunstadter, 1978.408

Growth, 1938/60

White marble; 109 × 44.5 × 28 cm (43 × 17 ½ × 11 in.)
Grant J. Pick Purchase Fund, 1965.357

Joan Miró

Spanish, 1893–1983

The Policeman, 1925

Oil on canvas; 248.4 × 198 cm (97 ¹³⁄₁₆ × 77 ¹⁵⁄₁₆ in.)
Bequest of Claire Zeisler, 1991.1499

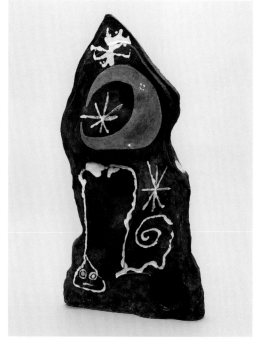

Joan Miró

Spanish, 1893–1983

Painting, summer 1936

Oil, gravel, pebbles, and sand on Masonite; 77.3 × 107 cm (30 ⁷⁄₁₆ × 42 ⅛ in.)
Gift of Florene May Schoenborn and Samuel A. Marx, 1950.1518

Stone, 1955

Earthenware; 82.7 × 41 × 12.7 cm (32 ½ × 16 ¼ × 5 in.)
Wirt D. Walker Fund, 1960.804

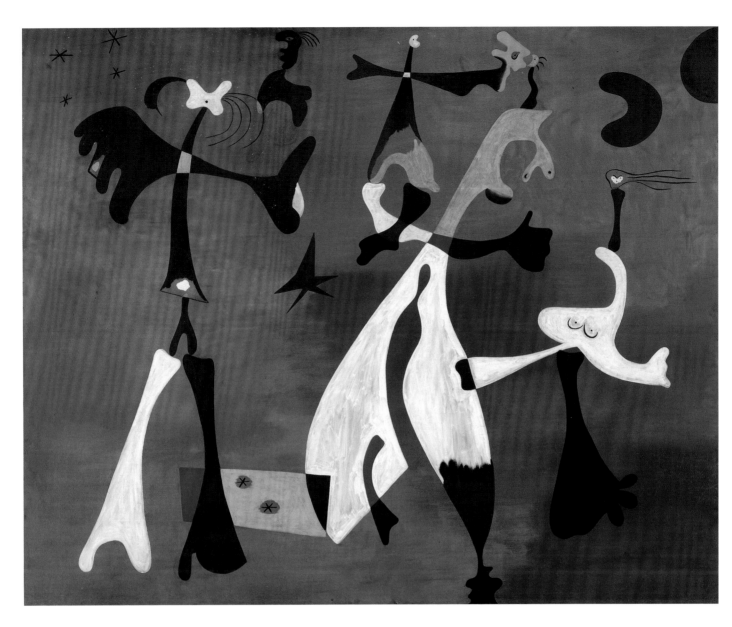

Joan Miró

Spanish, 1893–1983

Personages with Star, 1933

Oil on canvas; 199 × 247.1 cm (78 ⁵⁄₁₆ × 97 ¼ in.)
Gift of Mr. and Mrs. Maurice E. Culberg, 1952.512

Photography Credits

Unless otherwise noted, all photographs of the works in the catalogue were made by the Department of Imaging at the Art Institute of Chicago, Christopher Gallagher, Director of Photography, Louis Meluso, Director of Imaging Technology, and are copyrighted by the Art Institute of Chicago. Every effort has been made to contact and acknowledge copyright holders for all reproductions; additional rights holders are encouraged to contact the Art Institute of Chicago. The following credits apply to all images in this catalogue for which separate acknowledgment is due.

Front cover, pp. 13, 18, 41, 54–61: © 2014 Estate of Pablo Picasso / Artists Rights Society (ARS), New York; back cover, pp. 2, 11, 19 (left), 21, 46, 74–79: © 2014 Succession H. Matisse / Artists Rights Society (ARS), New York; p. 6: © Dave Jordano; pp. 10, 16, 19 (right), 22–24, 26–27, 40, 42 (left), 47, 50–51, 62, 64, 66, 71, 80, 82–85, 88, 90 (bottom left), 91, 99, 108–12, 114–17, 126 (top), 131: © 2014 Artists Rights Society (ARS), New York / ADAGP, Paris; p. 12 (left): Stephen Llewellen; pp. 12 (right), 124 (left), 128, 130: © Salvador Dalí, Fundació Gala-Salvador Dalí / Artists Rights Society (ARS), New York, 2014; p. 14: © Paul Warchol; pp. 30, 32–34, 37, 92, 94–95, 140: © Artists Rights Society (ARS), New York / VG Bild-Kunst, Bonn; p. 35 (left): © 2014 Estate of M. H. Maxy / Artists Rights Society (ARS), New York; p. 35 (right): © Nolde Stiftung Seebüll; p. 42 (right): © The Estate of Jacques Lipchitz, courtesy Marlborough Gallery, New York; p. 48: © Archives Marc et Ida Chagall, Paris; p. 52: courtesy of the Harry Ransom Center, The University of Texas at Austin; pp. 65, 70: © 2014 Artists Rights Society (ARS), New York / SIAE, Rome; pp. 68, 136, 138–39, 141–43: Successió Miró / Artists Rights Society (ARS), New York / ADAGP, Paris; p. 72: courtesy of George Eastman House, International Museum of Photography and Film; p. 86: Philadelphia Museum of Art, Archives, gift of Jacqueline, Paul, and Peter Matisse in memory of their mother Alexina Duchamp; pp. 89, 118, 123: © 2014 Man Ray Trust / Artists Rights Society (ARS), New York / ADAGP, Paris; p. 90 (top): © 2014 Artists Rights Society (ARS), New York / ADAGP, Paris / Succession Marcel Duchamp; pp. 98 (top), 101, 105 (left): © 2014 Mondrian / Holtzman Trust c/o HCR International, Washington, D.C.; p. 98 (bottom): © 2014 Artists Rights Society (ARS), New York / ADAGP, Paris / FLC; p. 102 (right): © Archives Exter-Lissim, Association Alexandra Exter, Paris 2013; p. 103: © 2014 Artists Rights Society (ARS), New York / ProLitteris, Zurich; p. 104: © 2014 Estate of Joaquin Torres Garcia; p. 106: © CNAC / NMAM / Dist. RMN-Grand Palais / Art Resource, NY, © 2014 Artists Rights Society (ARS), New York / ADAGP, Paris; p. 120: © 2014 Artists Rights Society (ARS), New York / SABAM, Brussels; p. 121 (left and top right): © 2014 Succession Giacometti / Artists Rights Society (ARS), New York / ADAGP, Paris; p. 121 (bottom right): © 2014 Artists Rights Society (ARS), New York / DACS, London; pp. 122, 129: © 2014 Estate of Yves Tanguy / Artists Rights Society (ARS), New York; pp. 124 (bottom right), 125, 127: © 2014 C. Herscovici, London / Artists Rights Society (ARS), New York; p. 126 (bottom): Succession Wolfgang Paalen and Eva Sulzer; pp. 132, 134–35: Art © The Joseph and Robert Cornell Memorial Foundation / Licensed by VAGA, New York, NY.